The stars are his bones

a photo-haiku portfolio
by Debiprasad Mukherjee

with a garland of Upanishadic texts arranged as haiku
by Gabriel Rosenstock

Cross-Cultural Communications
Merrick, New York
2021

Photo Editorial Guidance:
Mr. Sudipto Das. Principal Photojournalist. The Times of India.

Photo Editing & Book Design:
Bhaskar & Debiprasad Mukherjee

First Publication & Copyright:
Print Hard-Cover & Paperback Edition 2021
© Debiprasad Mukherjee & Gabriel Rosenstock
Non-Fiction. All rights reserved
e-book available

Published by:
Cross-Cultural Communications
Stanley H. Barkan, Editor-Publisher
239 Wynsum Avenue Merrick, NY 11566-4725/USA
Tel: 516/868-5635 Fax: 516/379-1901
Email: cccpoetry@aol.com

ISBN: 978-0-89304-708-5
Library of Congress Control Number: 2021947756

$40.00
ISBN 978-0-89304-708-5
54000>

9 780893 047085

ওঁ পূর্ণমদঃ পূর্ণমিদং পূর্ণাৎ পূর্ণমুদচ্যতে।
পূর্ণস্য পূর্ণমাদায় পূর্ণমেবাবশিষ্যতে।।
ওঁ শান্তিঃ শান্তিঃ শান্তিঃ ।।

অদঃ (সেই [অপ্রত্যক্ষ ব্রহ্ম, কারণ-ব্রহ্ম]); পূর্ণম্ (পূর্ণ [সর্ববাপী]); ইদম্ [নামরূপাত্মক দৃশ্যমান ব্রহ্ম, কার্য-ব্রহ্ম]); পূর্ণম্ (পূর্ণ [সর্বব্যাপী]); পূর্ণাৎ থেকে [কারণ-ব্রহ্ম]); পূর্ণম্ (পূর্ণ [কার্য-ব্রহ্ম]); উদচ্যতে (উদগত হয়); পূর্ণস্য (পূর্ণের [কার্য-ব্রহ্মের]); পূর্ণম্ (পূর্ণ); আদায় (গ্রহণ করলে ... সাহায্যে ব্রহ্ম হিসাবে); পূর্ণম্ এব (কেবল পূর্ণই [কেবল ব্রহ্মই]); ...শিষ্যতে (অবশিষ্ট থাকেন); শান্তিঃ ([হোক] শান্তি [আধ্যাত্মিক]); শান্তিঃ

in the beginning
nothing whatsoever
was here

ar dtús
ní raibh faic in aon chor
ann

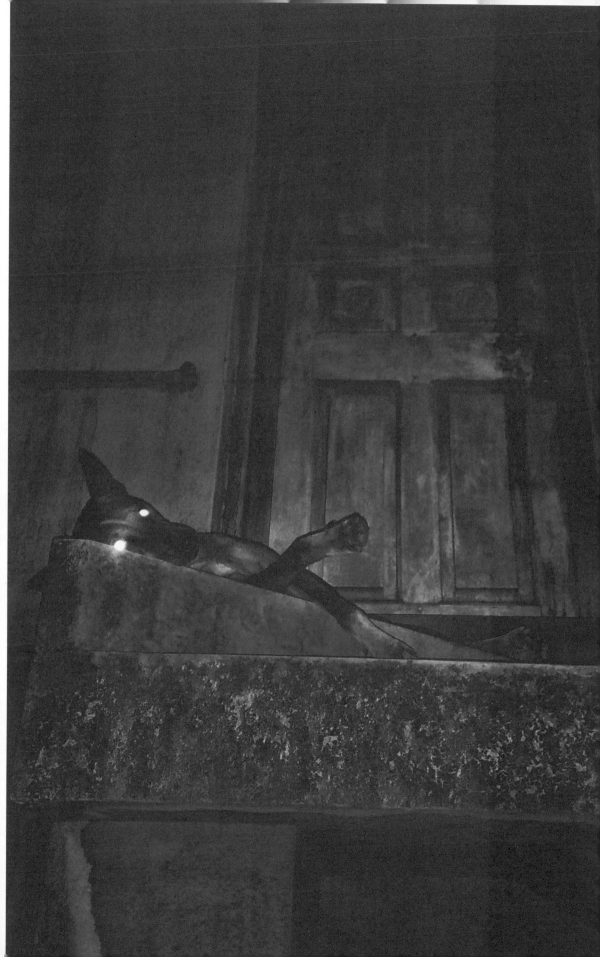

Shockingly Sublime...

Disorientation is an altered mental state, where confidence and certainty about location, identity, and time are suddenly challenged. Confusion results and an inability to think with normal clarity. The combined impact of these initially puzzling photographs and perplexing poems is that of a delayed explosion. As that initial shock of confusion recedes, the eye and brain sharpen to grapple with the riddle and to come to appreciate the skilled craftsmanship of poet and photographer working in tandem. These images, pictorial and poetic, disoriented before offering a glimpse of truth, a flash of revelation and the promise of understanding. Rosenstock's elegant but epigrammatic haiku trouvé strike like a rapier, while Mukherjee's images shift shape like a murmuration, forming and dissolving before us on the page. This beautiful production offers insight and wisdom in many shades, silhouettes, shadows, syllables and sounds to the reader willing to surrender to the experience; the reader willing to bathe in the sublimity offered here, a terrifying beauty conveying violence and poverty; the viewer that allows the images come to life before them. The Stars Are His Bones is a beautiful, stunning collaboration from different cultures, different media, different languages brought harmonious together into a cultural experience.

Brian (Breen) Ó Conchubhair
Director, Center for the Study of Languages & Cultures,
University of Notre Dame, USA

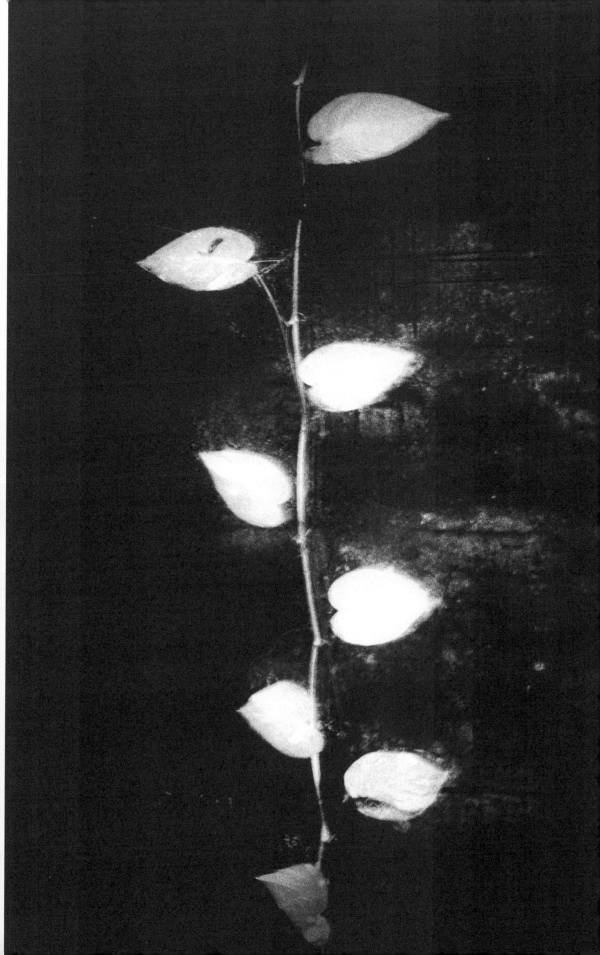

Out of the creative forge of this Irish wizard's prodigious imagination comes another fascinating hybrid work of art that defies classification. Innovatively collaborative, it threads a garland of Upanishad texts in Gabriel Rosenstock's exquisite literary haiku and weaves it through Debiprasad Mukherjee's photo-haiku portfolio to thrillingly resplendent effect. Spectacular imagery, precise and rustling with life, splices with richly evocative black-and-white photographs to grow and bloom in our minds in ways that we could have little anticipated, but to produce an illuminating revisualization of the world as if it were, and we with it, in the very act of its genesis. It leaves the eyes, and the mind with them, refreshingly cleansed in light—"the Chant is the gnat/is the fly/is the elephant." As I read it through, I forget which is the photograph and which the haiku. It is as if I am living in the essence of things, aware both of the oneness at the heart and their radiant particularity, their astonishing diversity.

Prof. Waqas A. Khwaja
Ellen Douglass Leyburn Professor of English
Agnes Scott College, Georgia; Poet and Critic

Mahanarayana Upanishad, Verse 1.1

अम्भस्यपारे भुवनस्य मध्ये नाकस्य पृष्ठे महतो महीयान् ।
शुक्रेण ज्योतींँषि समनुप्रविष्टः प्रजापतिश्चरति गर्भे अन्तः ॥

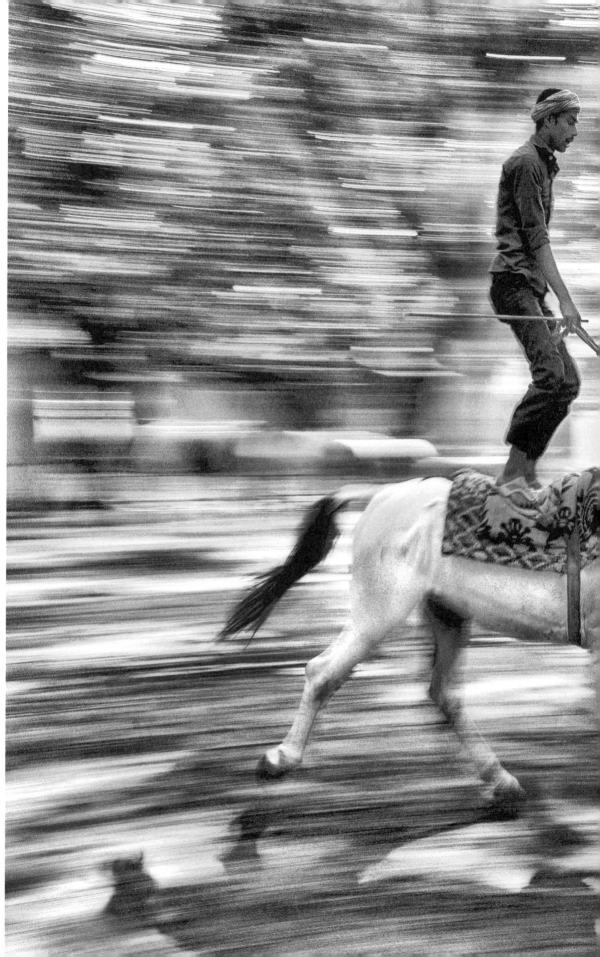

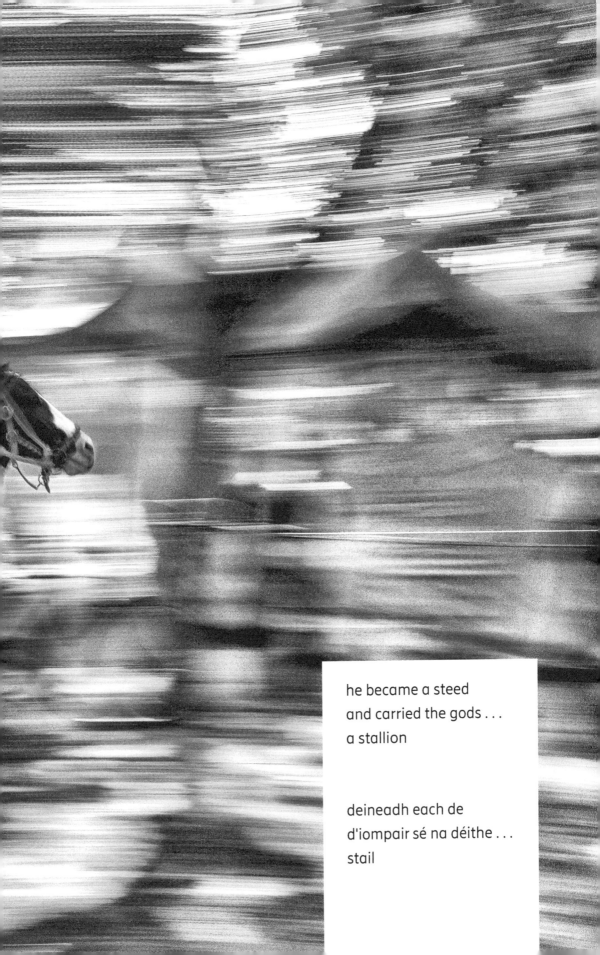

he became a steed
and carried the gods . . .
a stallion

deineadh each de
d'iompair sé na déithe . . .
stail

the stars are his bones
the clouds, his flesh . . .
rivers are his entrails

réaltaí iad a chnámha . . .
néalta a cholainn . . .
aibhneacha a ionathar

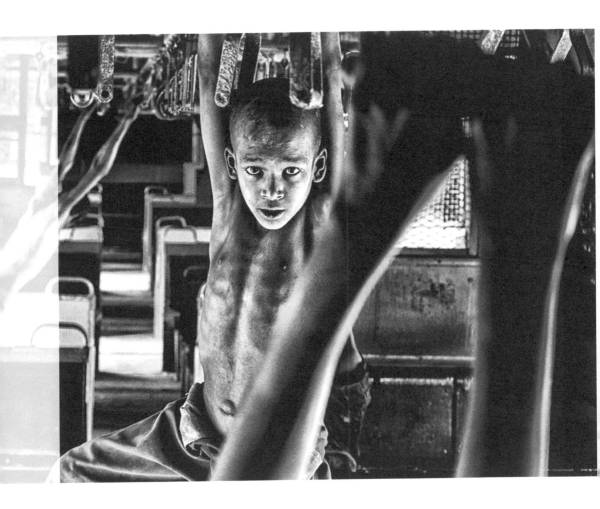

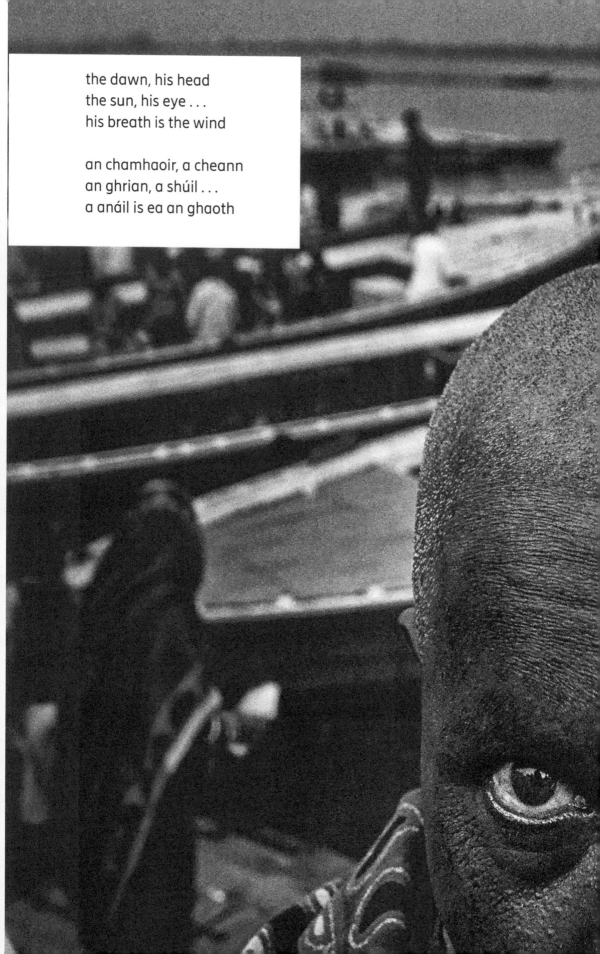

the dawn, his head
the sun, his eye . . .
his breath is the wind

an chamhaoir, a cheann
an ghrian, a shúil . . .
a anáil is ea an ghaoth

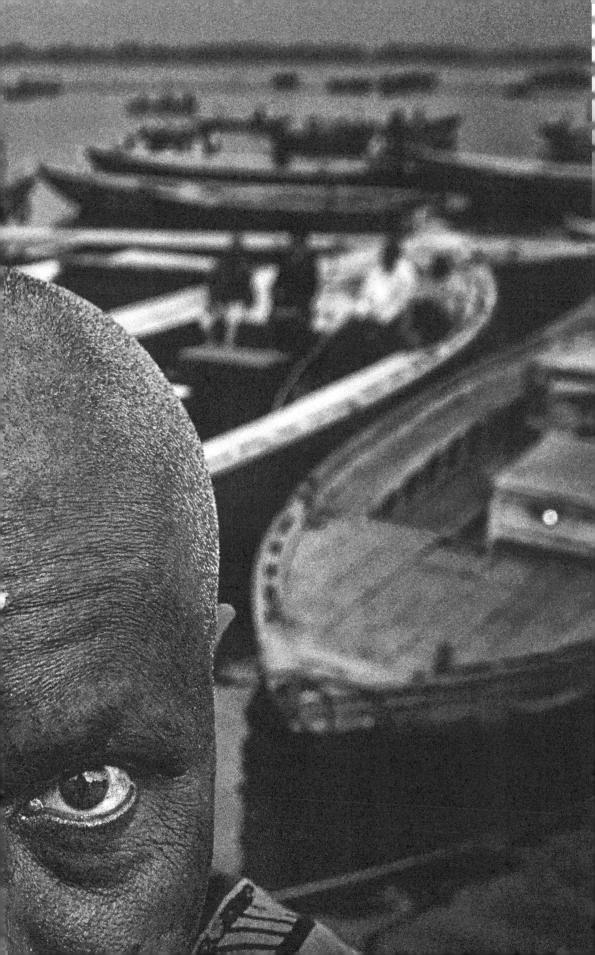

the foam of waters
hardened and became
the Earth

d'éirigh cúr na n-uiscí
crua agus deineadh
an Domhan de

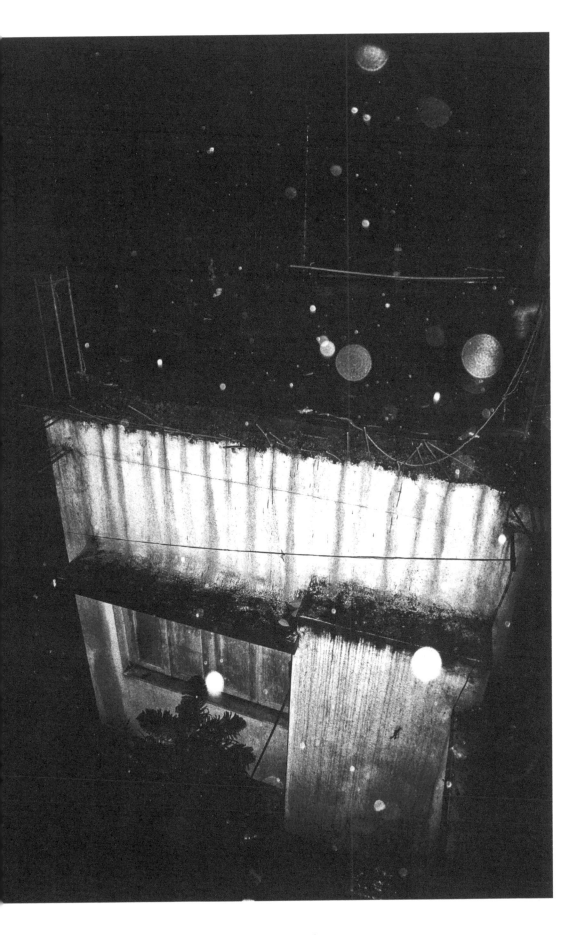

semen became the year . . .
prior to that
no year ever was

dá shíol deineadh an bhliain . . .
roimhe sin
ní raibh bliain ar bith ann

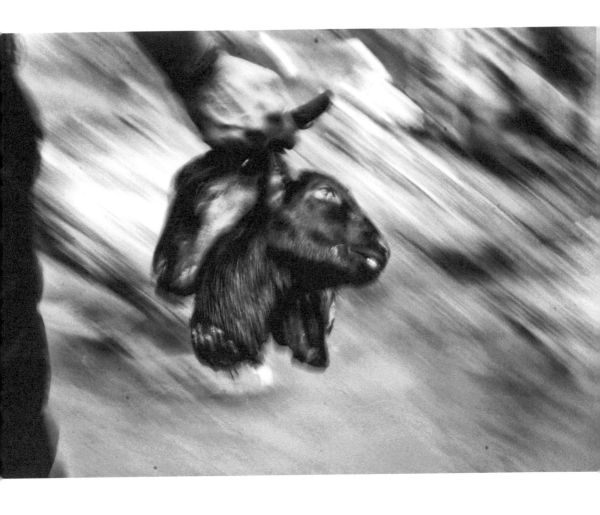

when he came on earth
Death opened his mouth for him . . .
he cried out, Bhān!

nuair a saolaíodh é
d'oscail an Bás a bhéal dó . . .
ar sé de bhéic, Bhān!

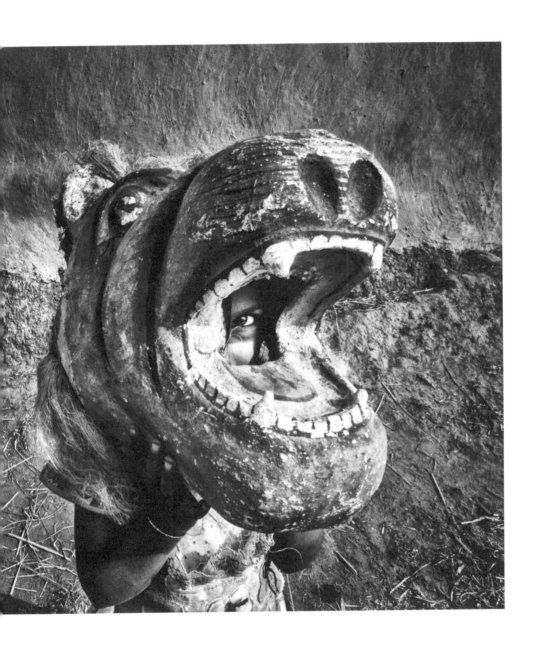

the gods said to Speech
'sing for us!'
and Speech sang

arsa na déithe le hUrlabhra
'can dúinn!'
is chan Urlabhra

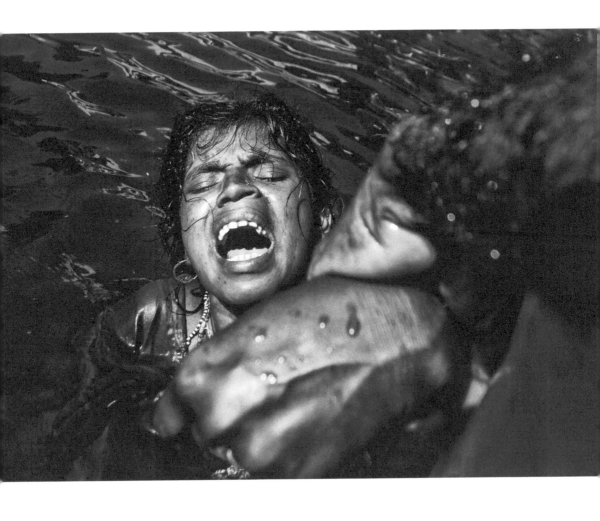

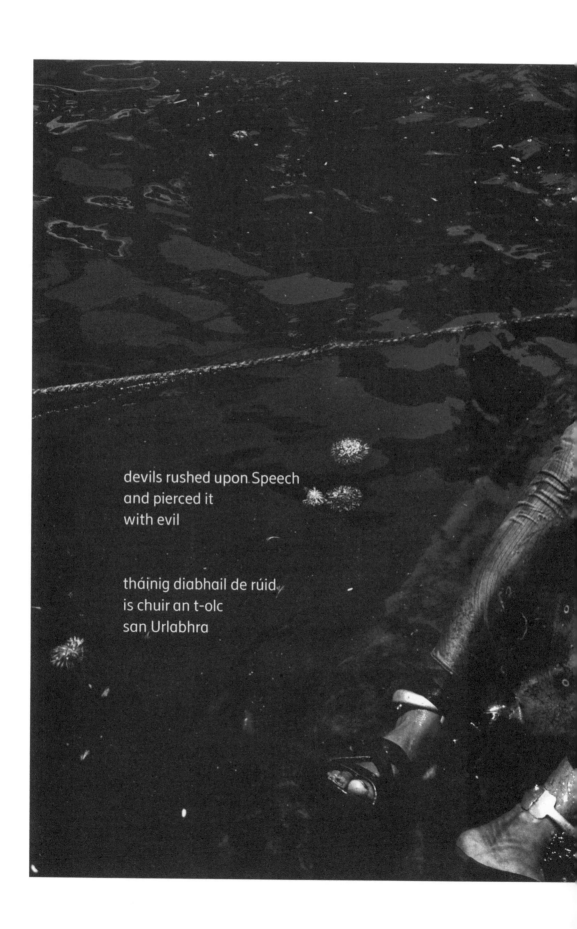

devils rushed upon Speech
and pierced it
with evil

tháinig diabhail de rúid
is chuir an t-olc
san Urlabhra

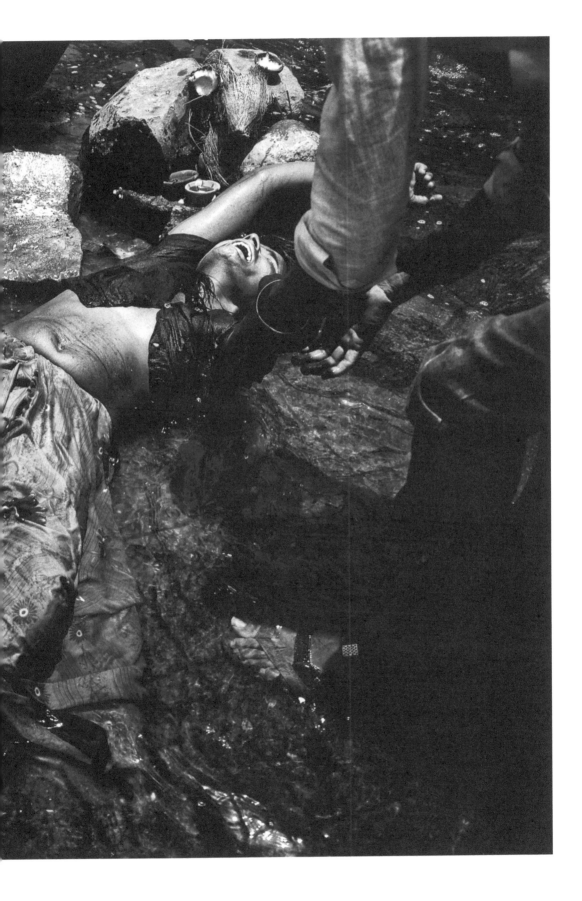

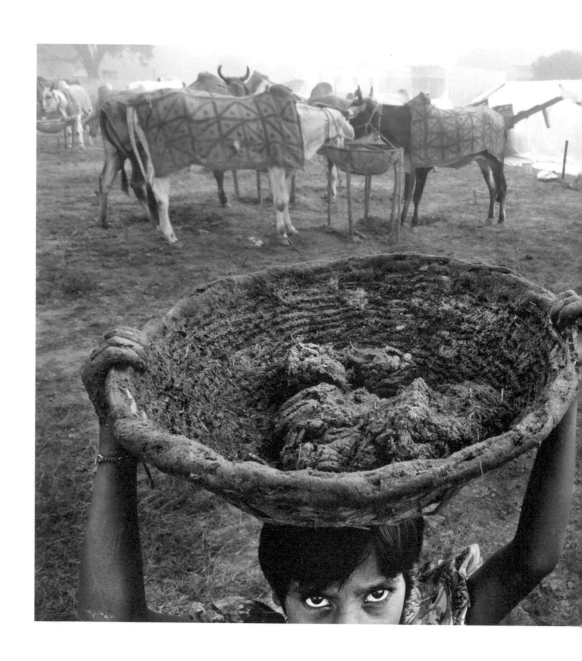

the gods said to the Eye
'sing for us!'
and the Eye sang

arsa na déithe leis an tSúil
'can dúinn!'
is chan an tSúil

devils rushed upon the Eye
and pierced it
with evil

tháinig diabhail de rúid
is chuir an t-olc
sa tSúil

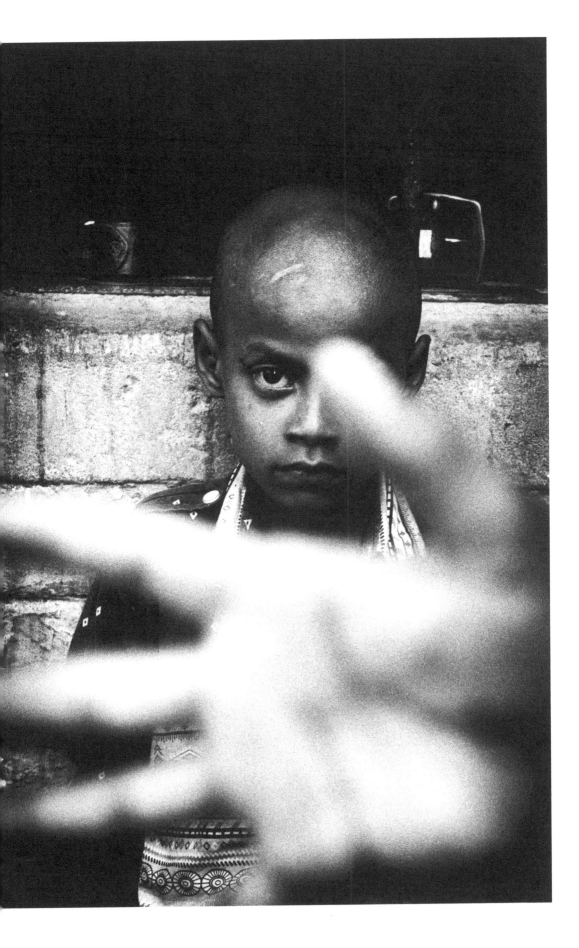

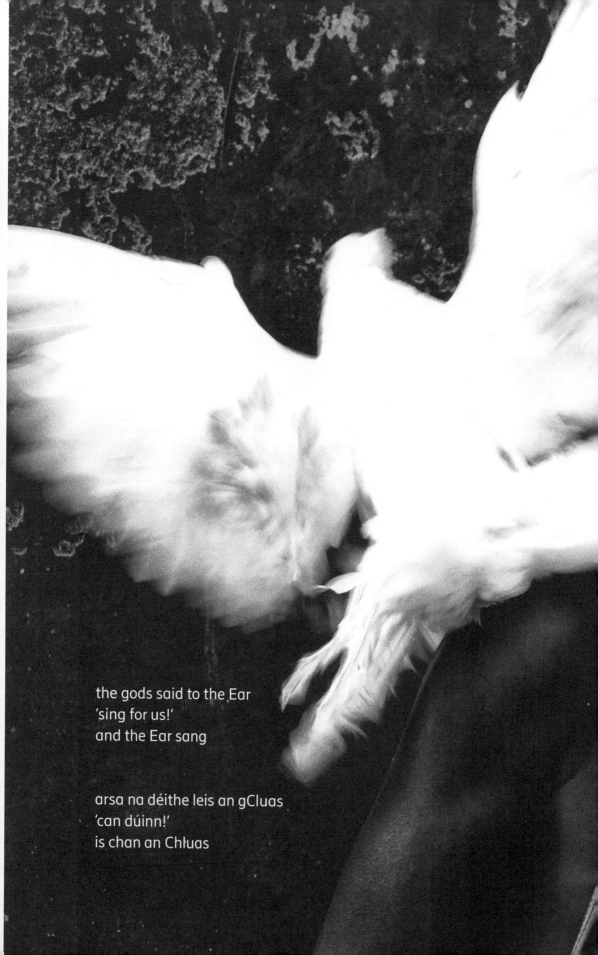

the gods said to the Ear
'sing for us!'
and the Ear sang

arsa na déithe leis an gCluas
'can dúinn!'
is chan an Chluas

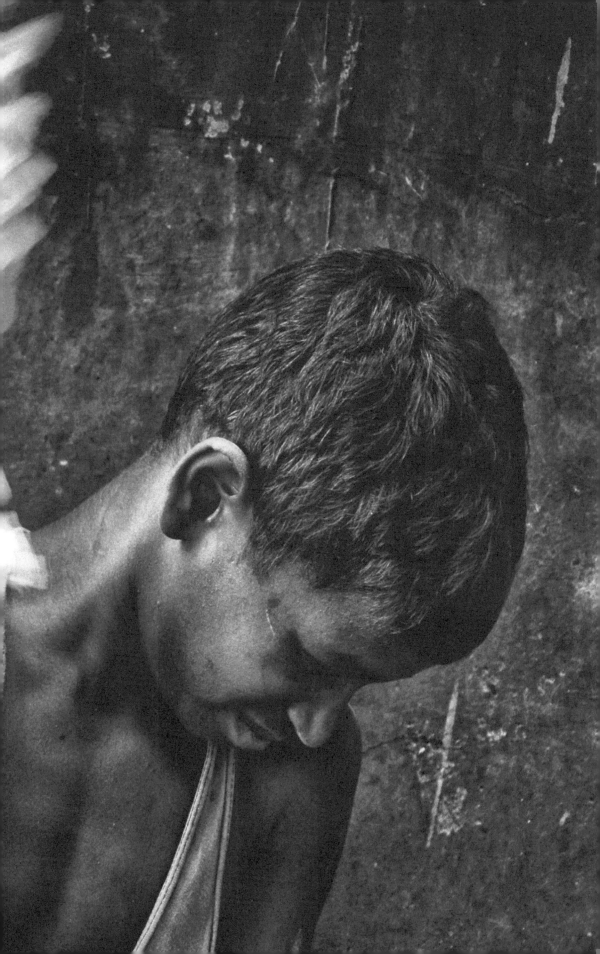

devils rushed upon the Ear
and pierced it
with evil

tháinig diabhail de rúid
is chuir an t-olc
sa Chluas

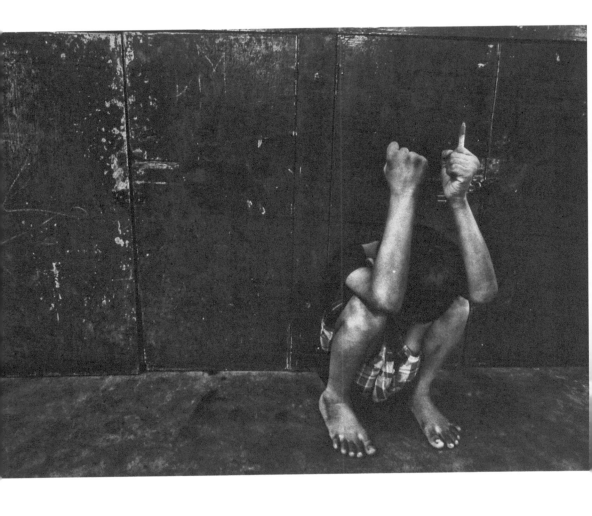

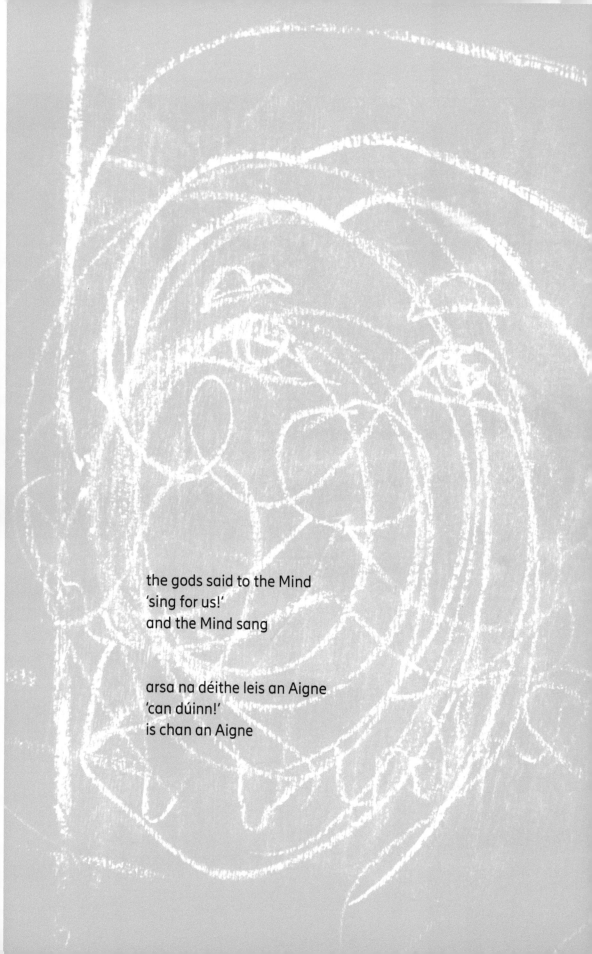

the gods said to the Mind
'sing for us!'
and the Mind sang

arsa na déithe leis an Aigne
'can dúinn!'
is chan an Aigne

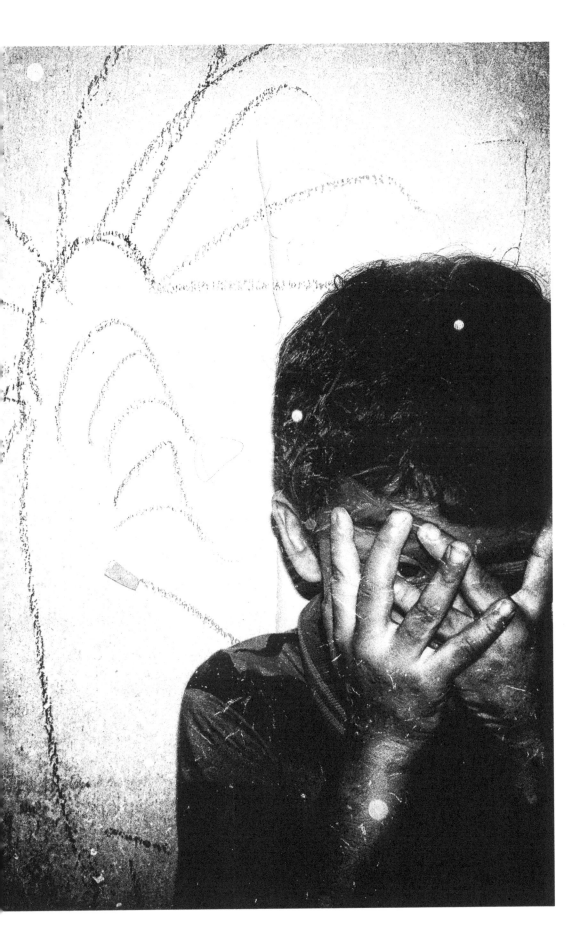

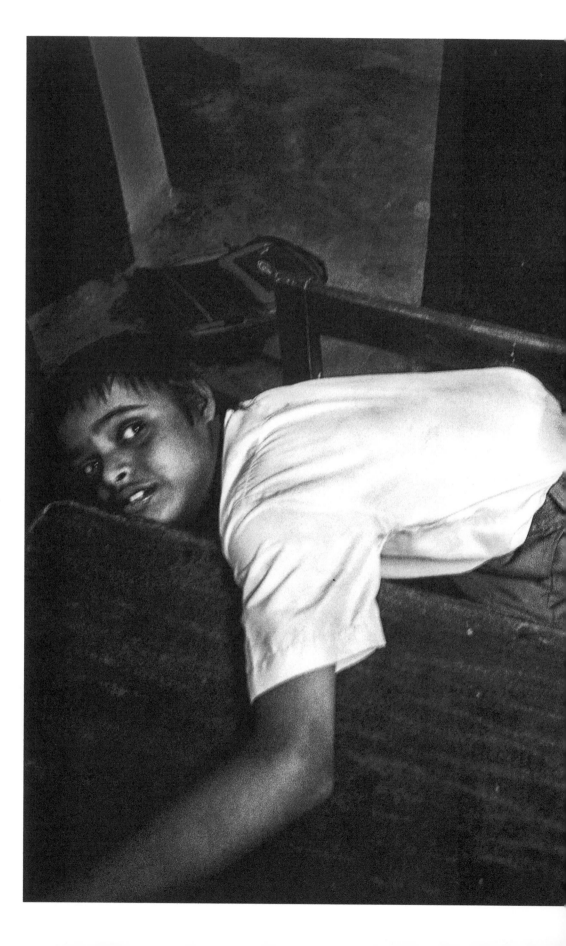

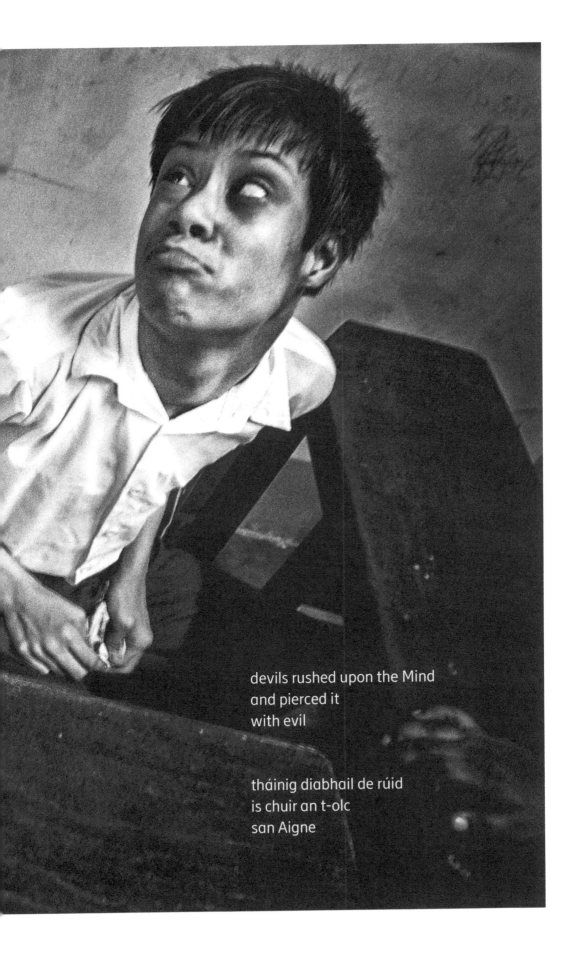

devils rushed upon the Mind
and pierced it
with evil

tháinig diabhail de rúid
is chuir an t-olc
san Aigne

the gods said to Breath
'sing for us!'
and Breath sang

arsa na déithe leis an Anáil
'can dúinn!'
is chan an Anáil

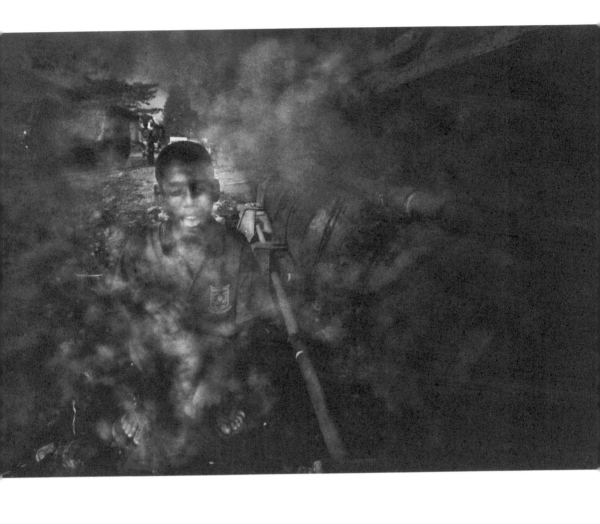

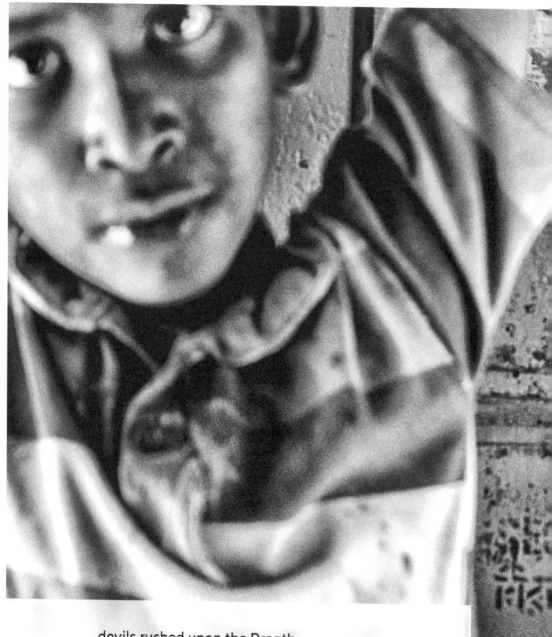

devils rushed upon the Breath
and they were all scattered
to the four winds

tháinig diabhail de rúid
is cuireadh scaipeadh
na mionéan orthu go léir

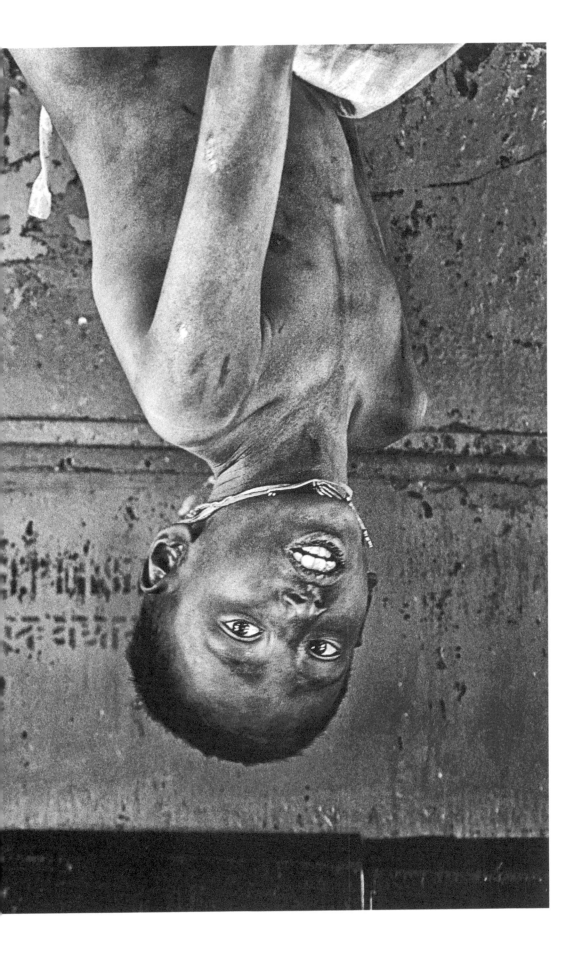

The Kaivalya Upanishad. Verses 16-17

ॐ

यत्परं ब्रह्म सर्वात्मा विश्वस्यायतनं महत् ।
सूक्ष्मात्सूक्ष्मतरं नित्यं तत्त्वमेव त्वमेव तत् ॥

the Chant is sāman
sā is 'she'
ama is 'he'

Cantaireacht is ea sāman
sā is ea 'ise'
ama is ea 'eisean'

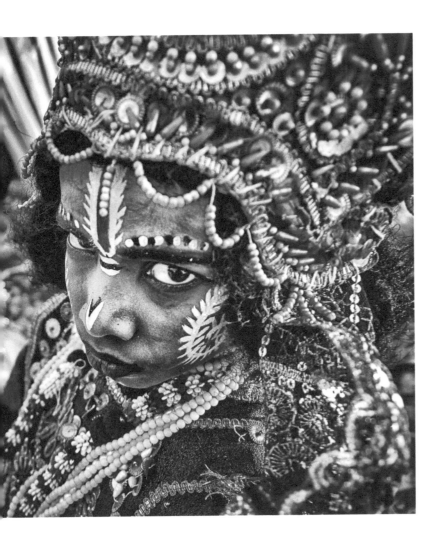

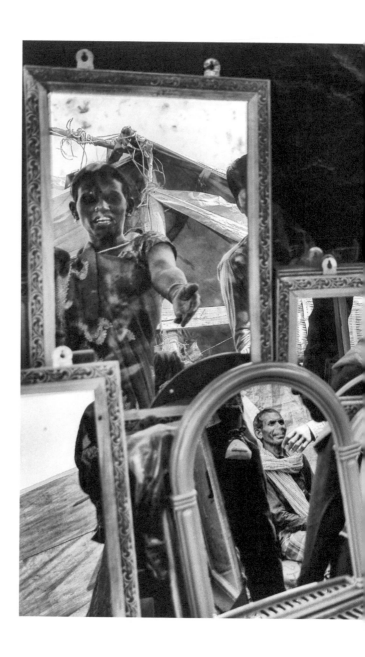

the Chant is the gnat
is the fly
is the elephant

corrmhíol is ea an Chantaireacht
cuileog is ea í
eilifint

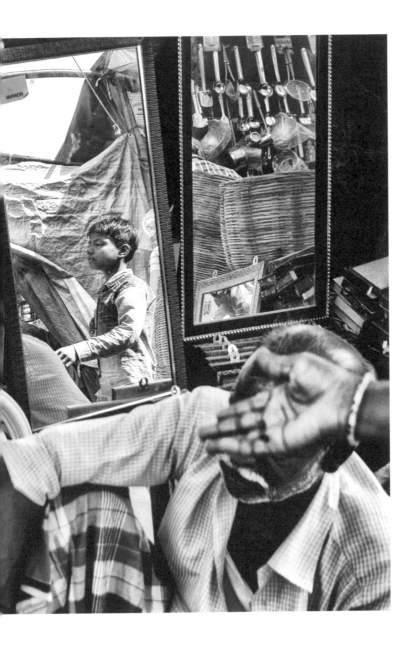

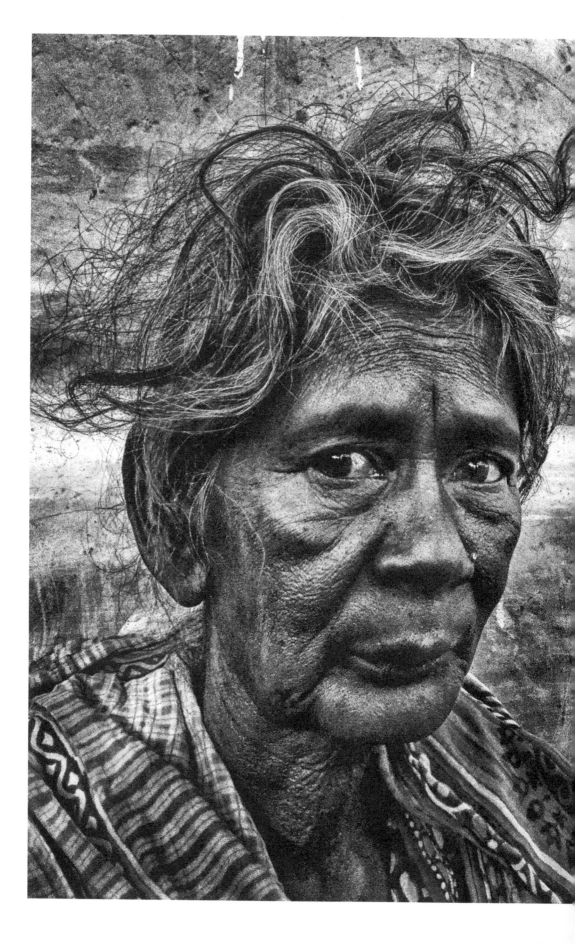

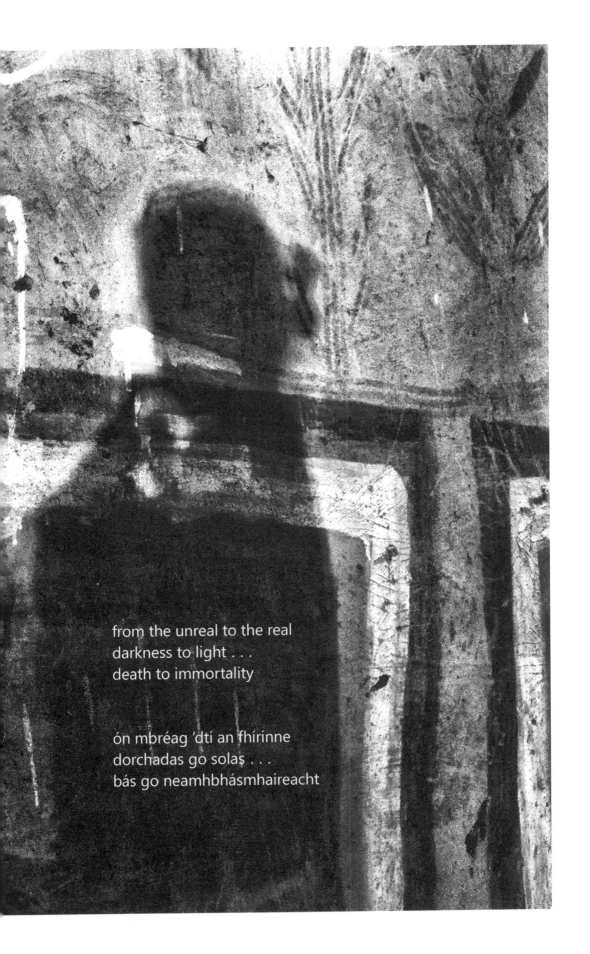

from the unreal to the real
darkness to light . . .
death to immortality

ón mbréag 'dtí an fhírinne
dorchadas go solas . . .
bás go neamhbhásmhaireacht

since there is nothing else
but myself
of what am I afraid?

cad a chuirfeadh eagla orm?
níl aon ní ann
lasmuigh díom féin

you are the dark-blue bird
green parrot with red eyes . . .
lightning is your child

is tú an t-éan gorm dorcha
pearóid na súl dearg . . .
is tintreach é do leanbh

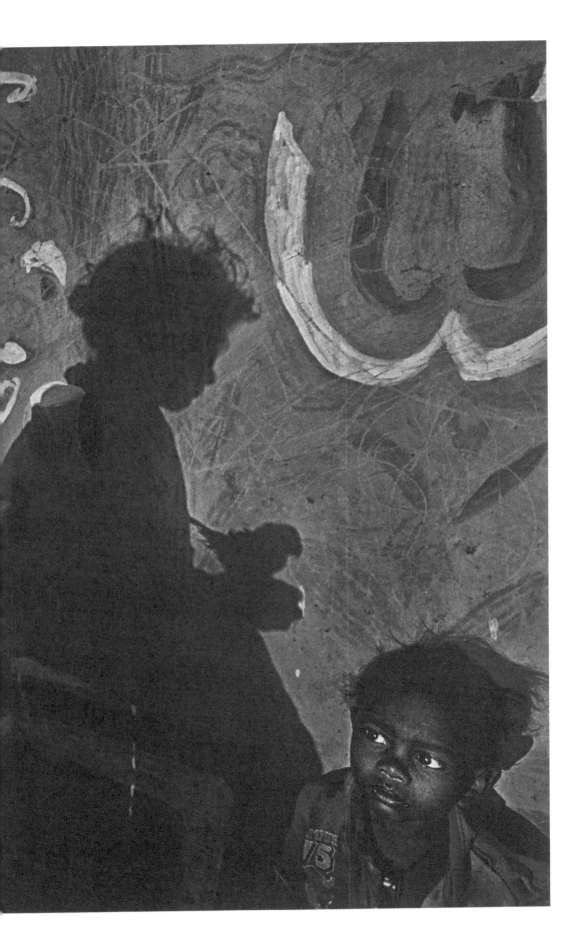

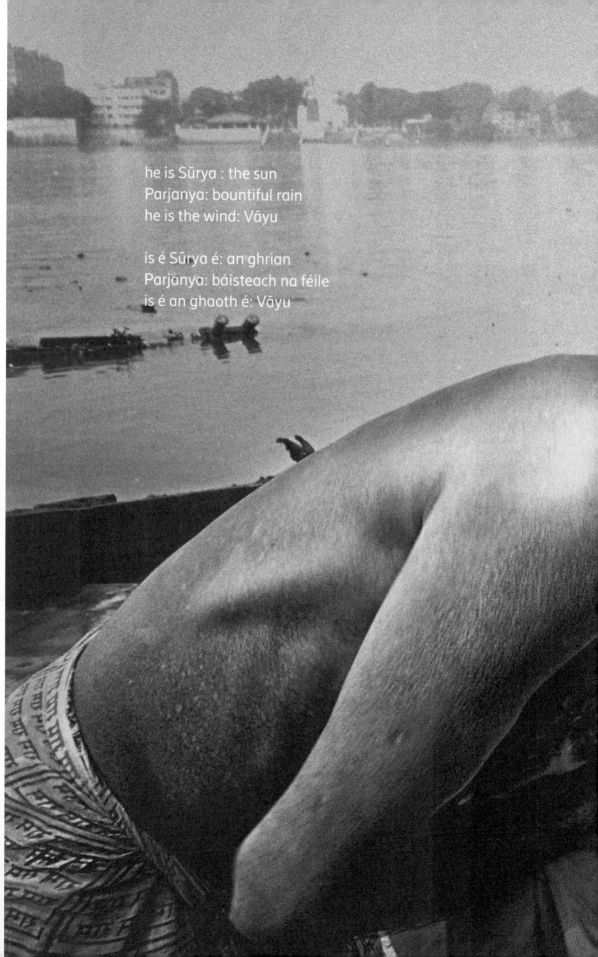

he is Sūrya : the sun
Parjanya: bountiful rain
he is the wind: Vāyu

is é Sūrya é: an ghrian
Parjanya: báisteach na féile
is é an ghaoth é: Vāyu

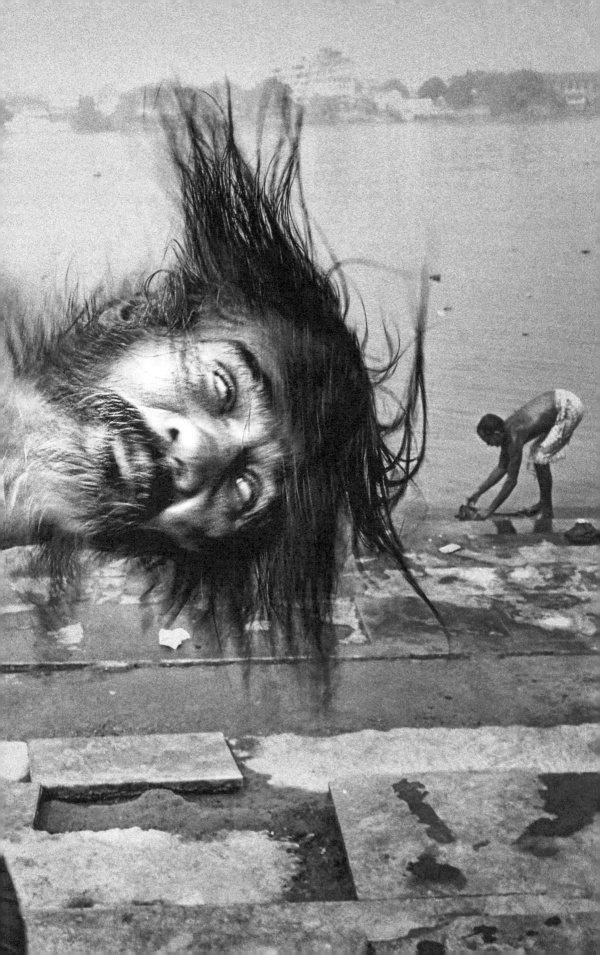

it moves, moves not
it is within . . .
without

bogann sé, ní bhogann
istigh atá sé . . .
amuigh

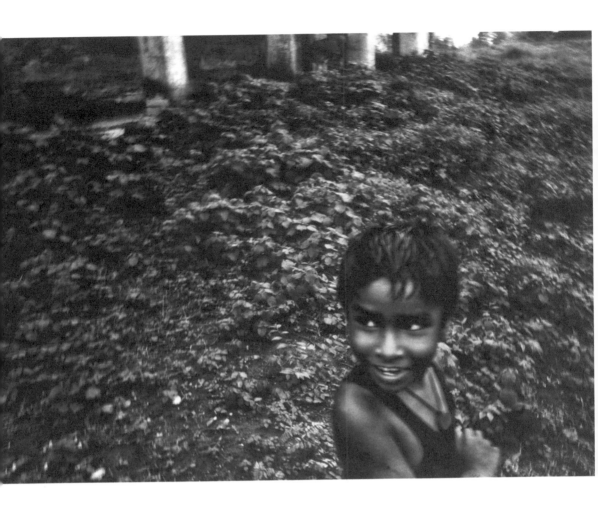

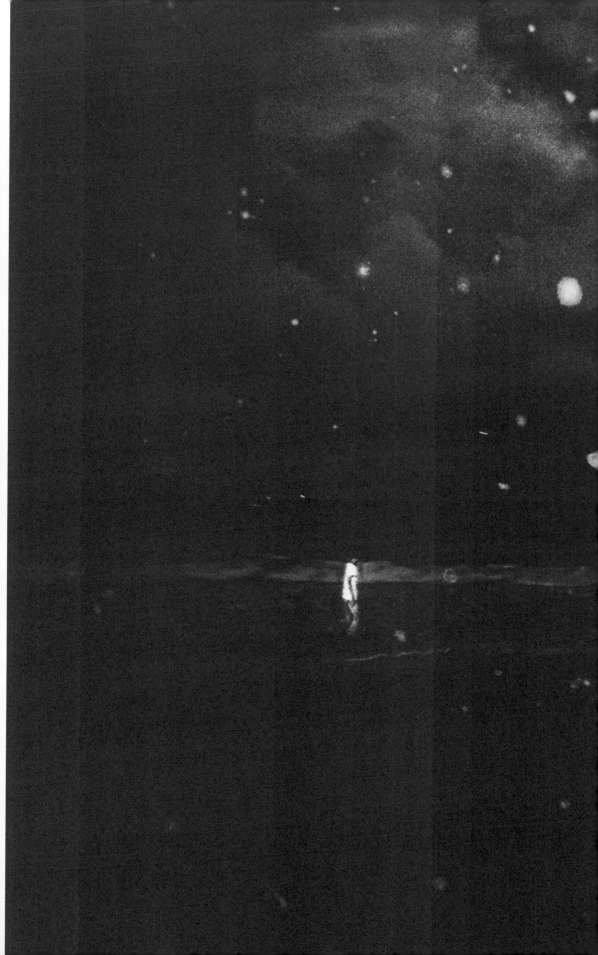

the seer sees not death
nor sickness, nor distress . . .
only the All

ní fheiceann an saoi an bás
ná tinneas ná buairt . . .
ní fheiceann sé ach an tIomlán

Pavamana Mantra.
The Brihadaranyaka Upanishad. Verse 1.3.28

ॐ असतो मा सद्गमय ।
तमसो मा ज्योतिर्गमय ।
मृत्योर्मा अमृतं गमय ।
ॐ शान्तिः शान्तिः शान्तिः ॥

he is the world-protector
world-sovereign, lord of all . . .
my self

cosantóir an domhain
rí na cruinne, tiarna os cionn cách . . .
mé féin

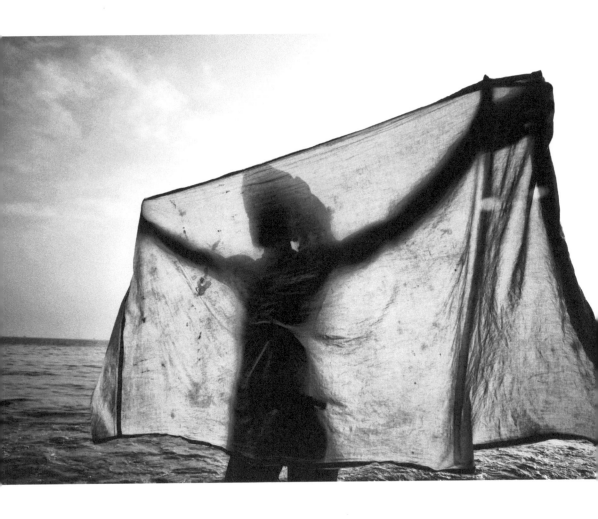

edge of a razor
hard to traverse . . .
so poets declare

faobhar rásúir
deacair a thrasnú . . .
dar leis na filí

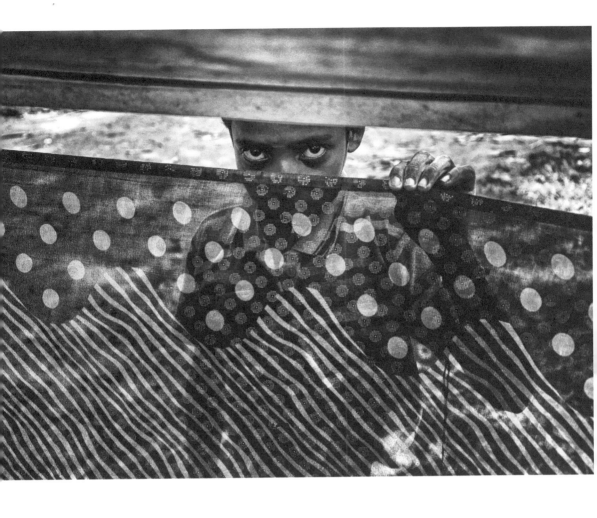

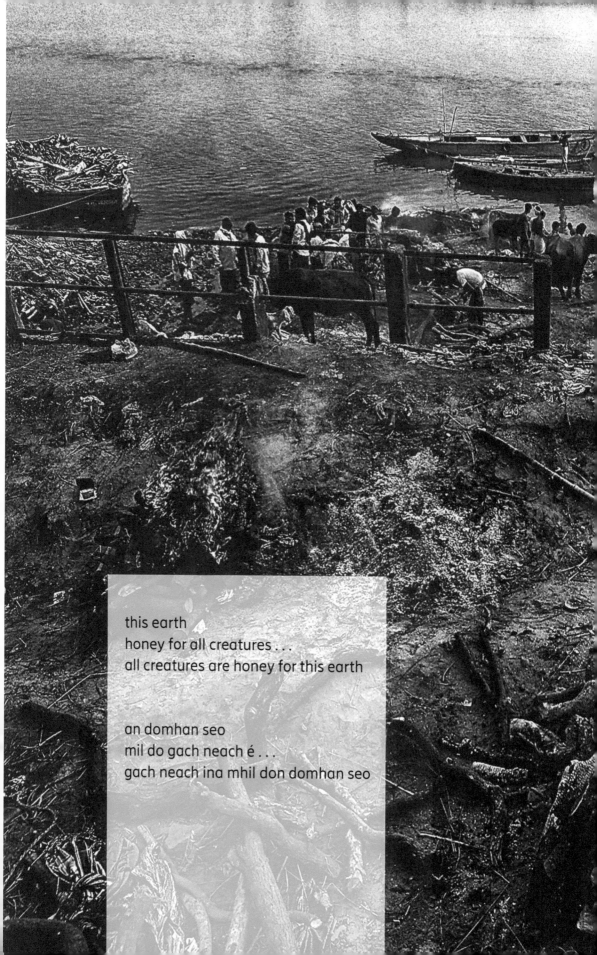

this earth
honey for all creatures . . .
all creatures are honey for this earth

an domhan seo
mil do gach neach é . . .
gach neach ina mhil don domhan seo

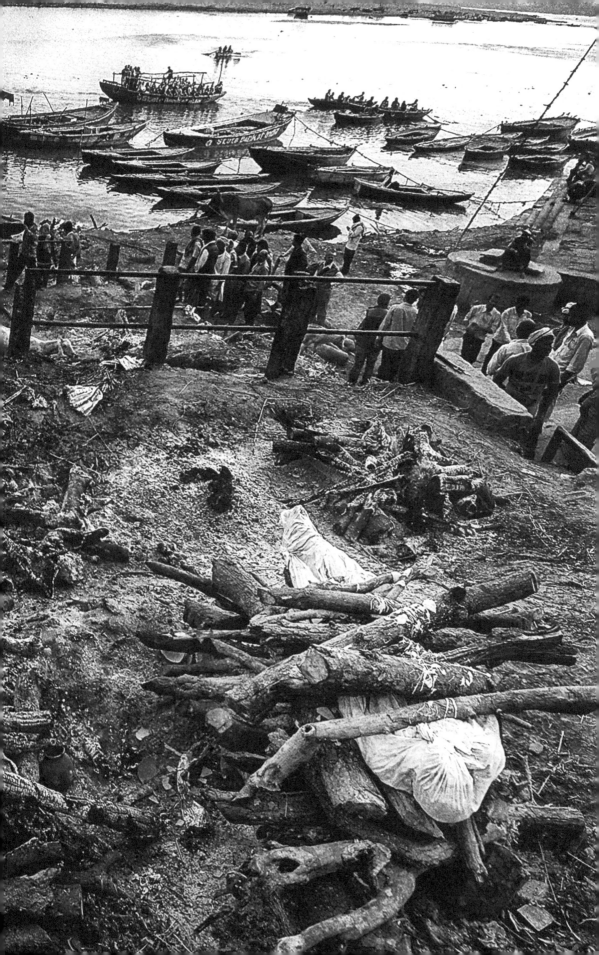

these waters
honey for all things . . .
all things are honey for these waters

na huiscí seo
mil do gach aon ní iad . . .
gach ní ina mhil do na huiscí seo

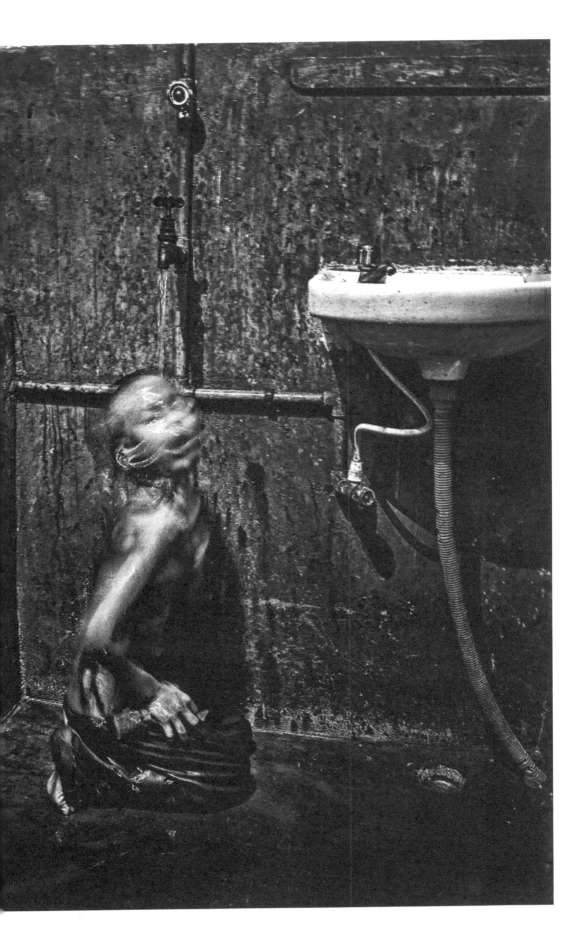

this fire is
honey for all things . . .
all things are honey for this fire

an tine seo
ina mil do gach aon ní . . .
gach ní ina mhil don tine seo

this wind is
honey for all things . . .
all things are honey for this wind

an ghaoth seo
ina mil do gach aon ní . . .
gach ní ina mhil don ghaoth seo

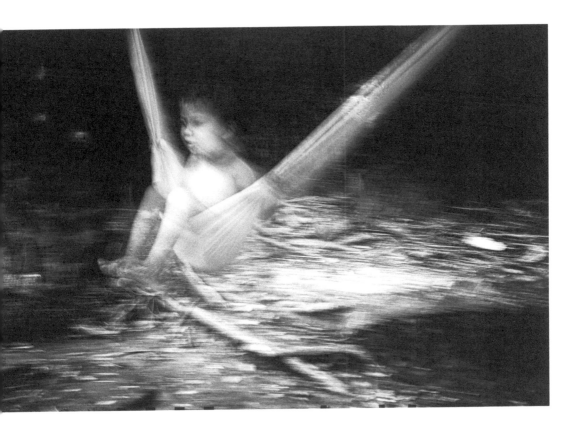

this sun
is honey for all things . . .
all things are honey for this sun

an ghrian seo
ina mil do gach aon ní . . .
gach ní ina mhil don ghrian seo

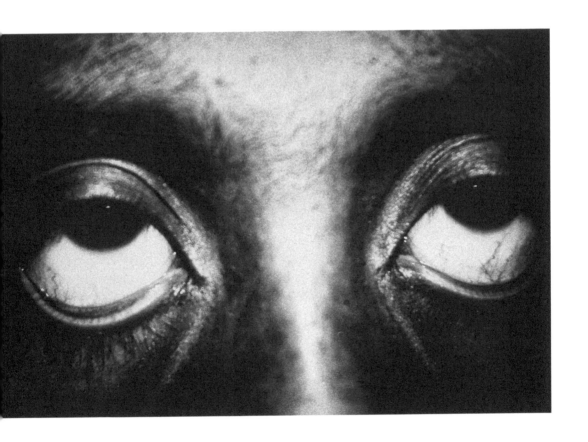

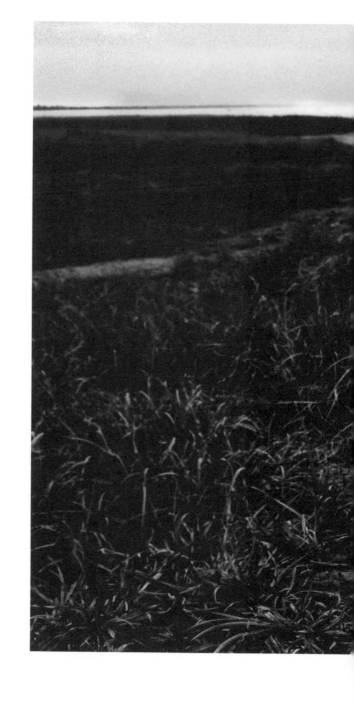

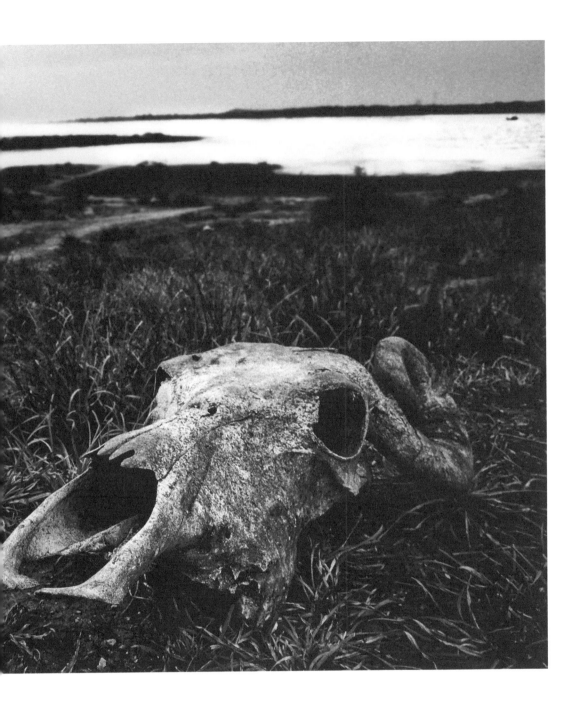

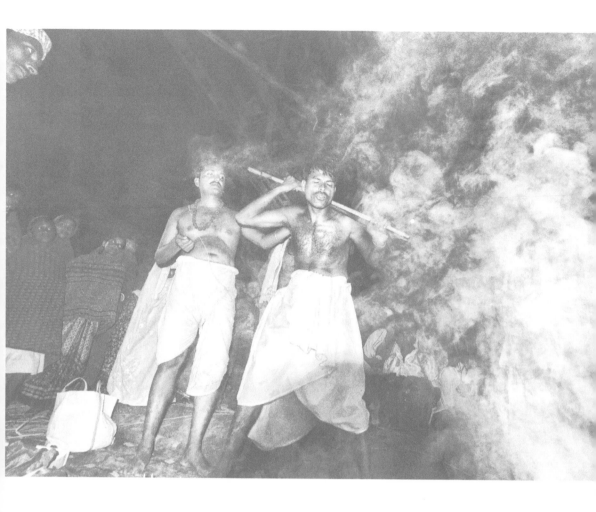

from earth
from fire . . .
divine Speech enters him

ón domhan
ón tine . . .
gabhann Urlabhra dhiaga ann

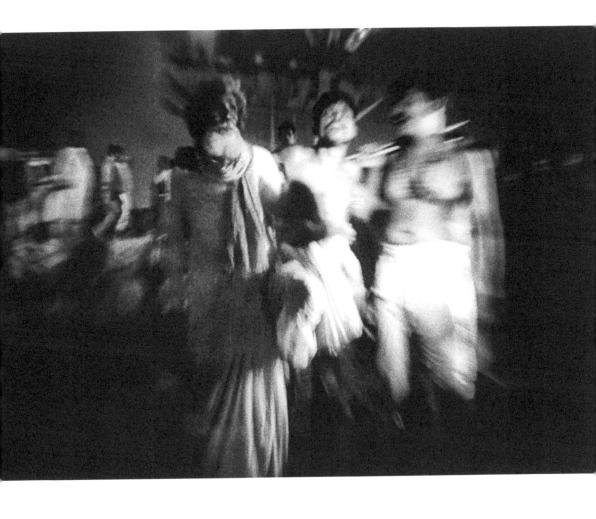

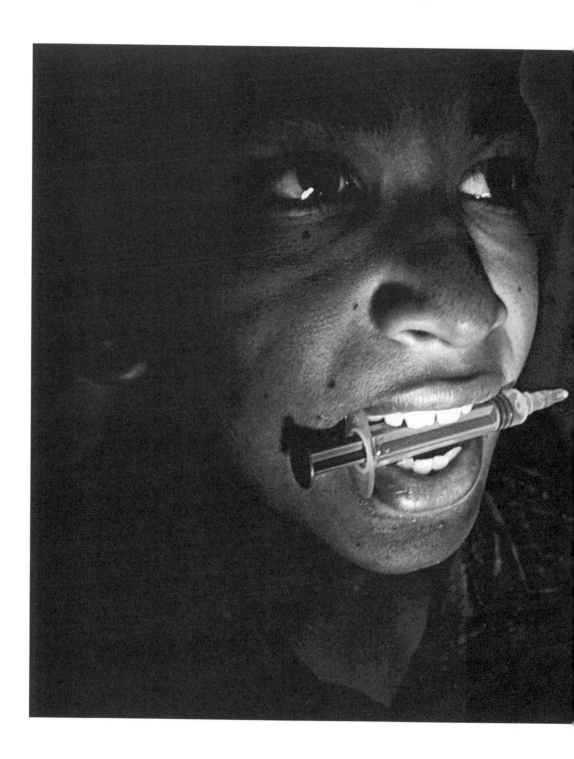

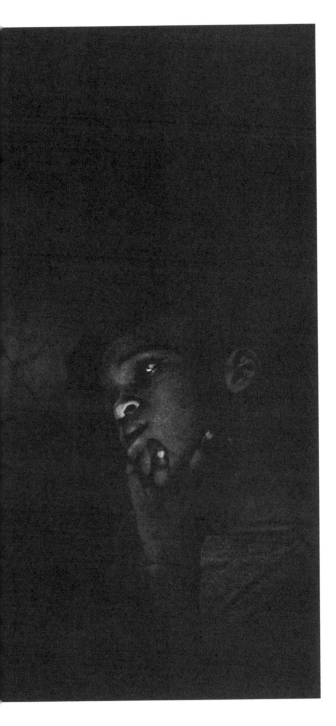

out of the sky
out of the sun . . .
divine Mind enters him

as an spéir
as an ngrian . . .
gabhann Aigne dhiaga ann

out of water
out of the moon . . .
divine Breath enters him

as uisce
as an ngealach . . .
gabhann Anáil dhiaga ann

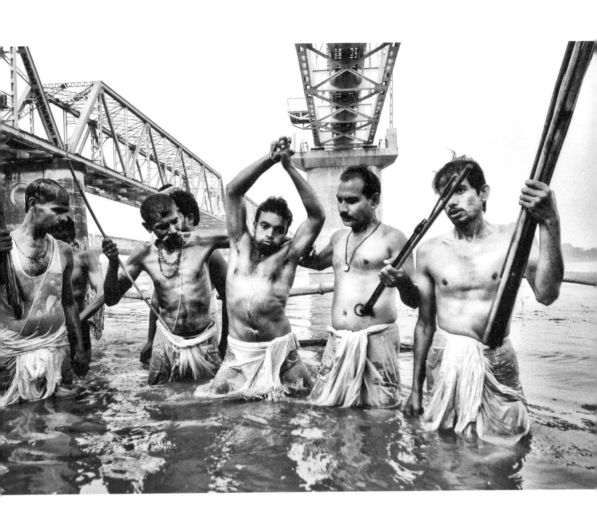

oh, how wonderful
how wonderful, oh
oh, how wonderful!

ó, nach breá é
nach breá é, ó
ó nach breá é!

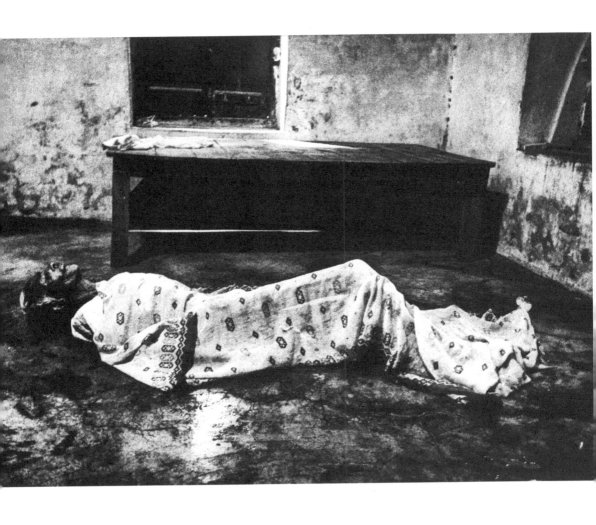

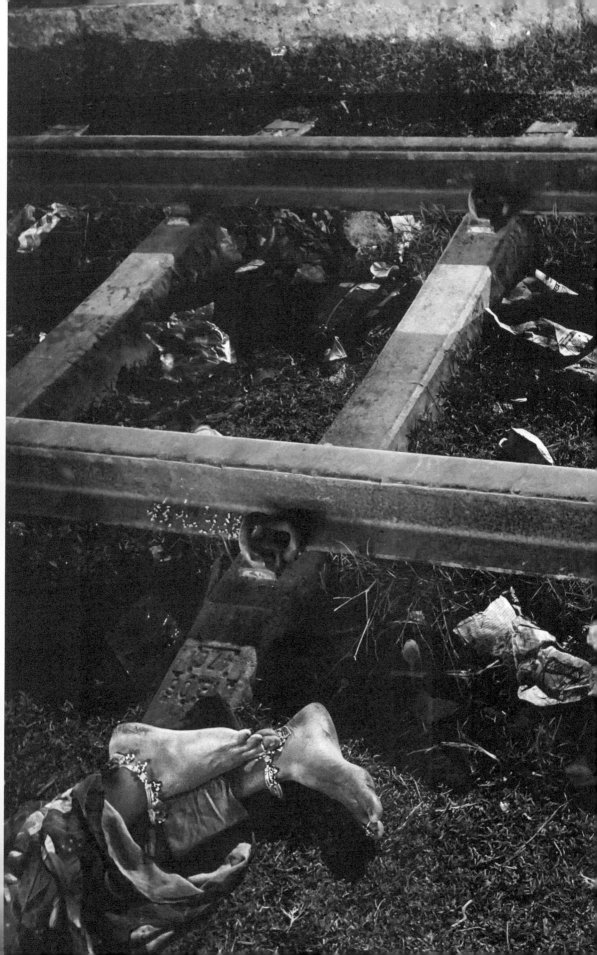

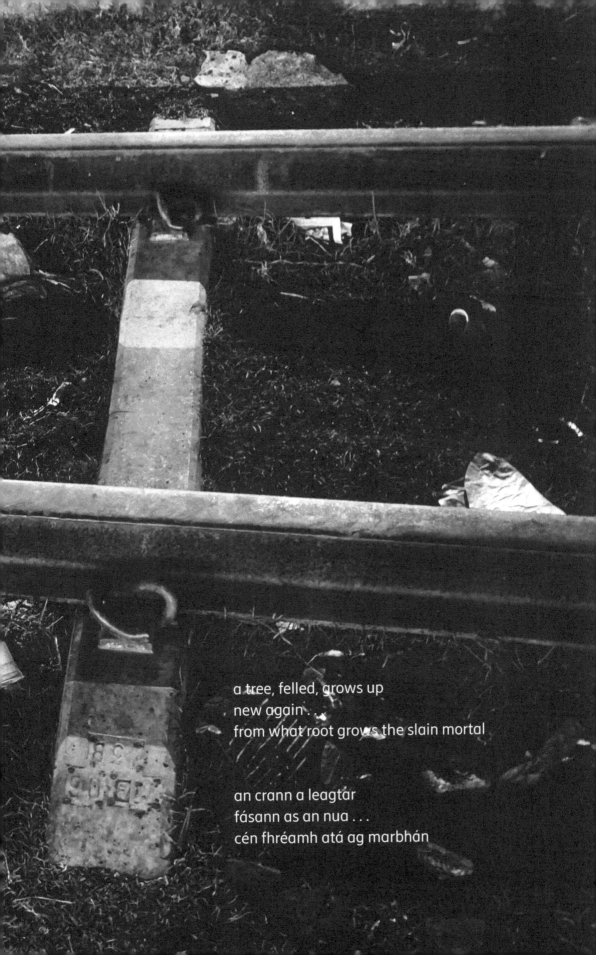

a tree, felled, grows up
new again . . .
from what root grows the slain mortal

an crann a leagtar
fásann as an nua . . .
cén fhréamh atá ag marbhán

sun has set and moon has set
fire gone out
what light is there

grian is gealach ina luí
tine múchta . . .
cén léas atá ann

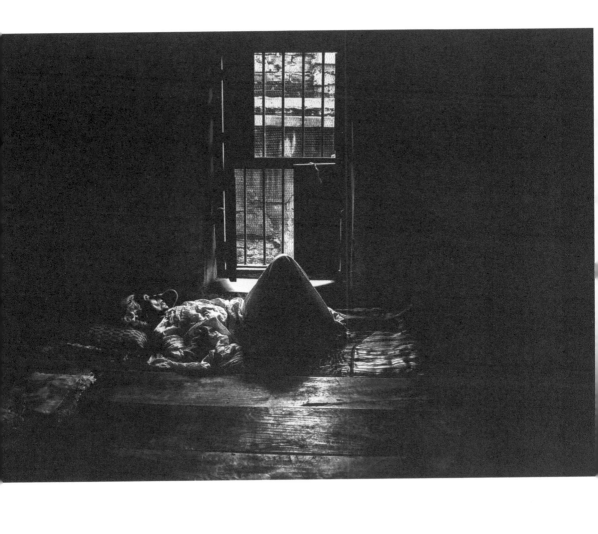

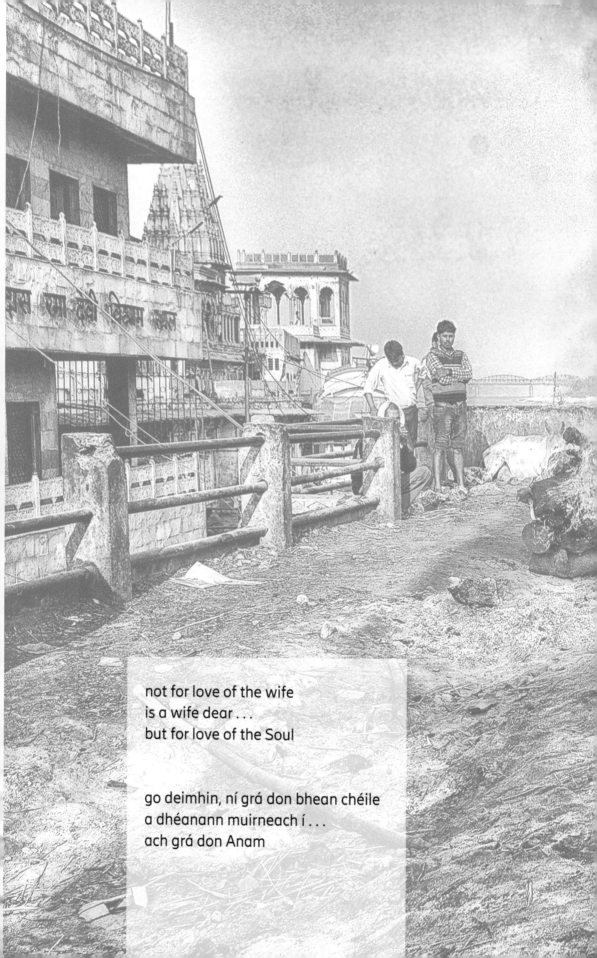

not for love of the wife
is a wife dear . . .
but for love of the Soul

go deimhin, ní grá don bhean chéile
a dhéanann muirneach í . . .
ach grá don Anam

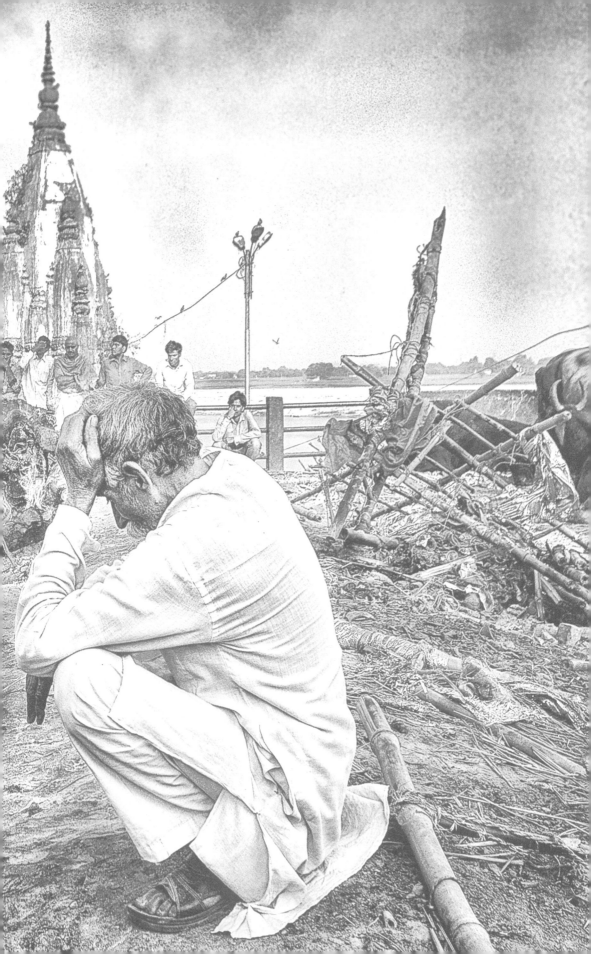

not for love of the sons
are sons dear . . .
but for love of the Soul

go deimhin, ní grá don chlann mhac
a dhéanann muirneach iad . . .
ach grá don Anam

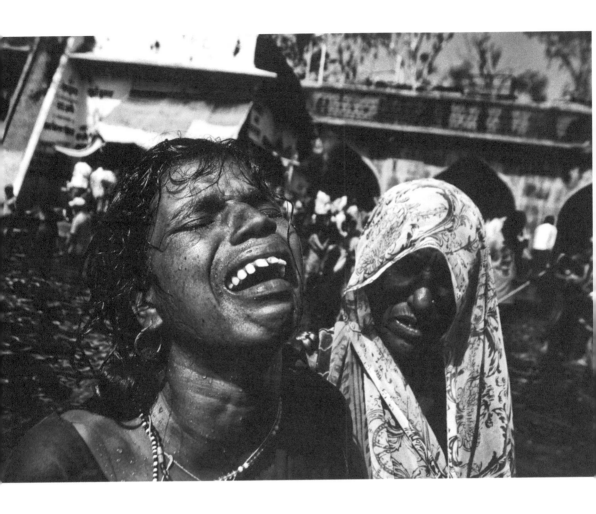

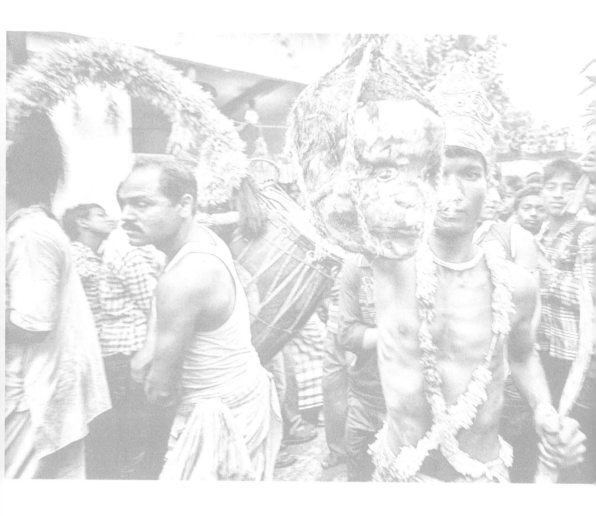

he is becoming One, he does not see
he does not smell
he does not taste

déanfar Aon de, ní fheiceann sé
ní bholaíonn sé
ní bhlaiseann sé

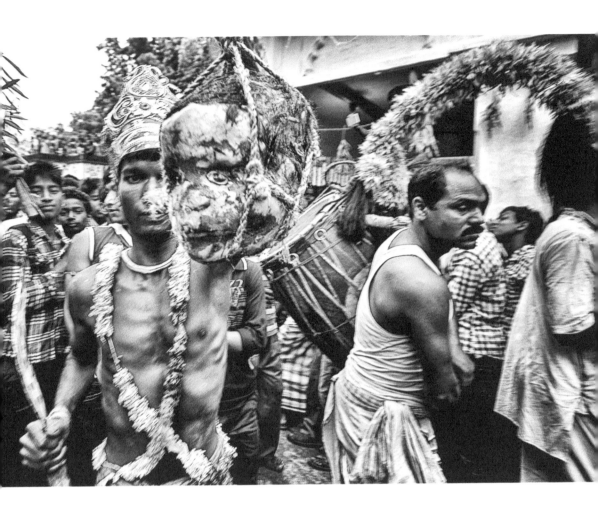

he is becoming One, he does not speak
does not hear
does not think

déanfar Aon de, ní labhraíonn sé
ní chloiseann sé
ní smaoiníonn sé

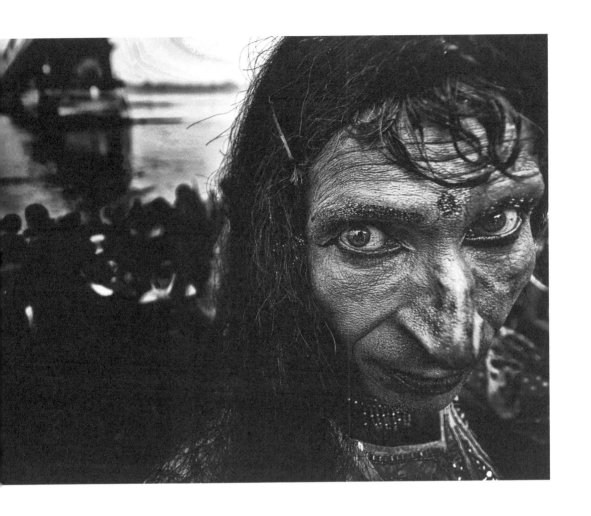

Shanti Mantra.
The Isha Upanishad - Part of (Shukla) Yajurveda). Verse 1

ॐ

ॐ पूर्णमदः पूर्णमिदं पूर्णात्पूर्णमुदच्यते ।
पूर्णस्य पूर्णमादाय पूर्णमेवावशिष्यते ॥
ॐ शान्तिः शान्तिः शान्तिः ॥

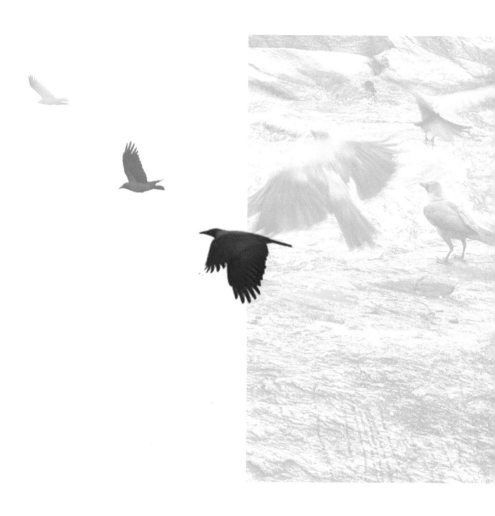

these rivers, my dear
towards the east they flow . . .
westwards they go

na haibhneacha seo, a thaisce
gabhann siad soir . . .
siar a ghabhann

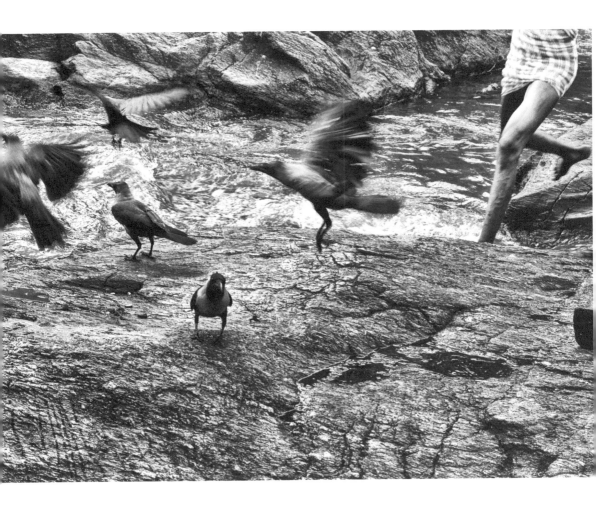

from ocean to ocean
they become ocean itself
we all come forth from Being

ó aigeán go haigéan
is déantar aigéan díobh . . .
as an mBeith dúinne uile

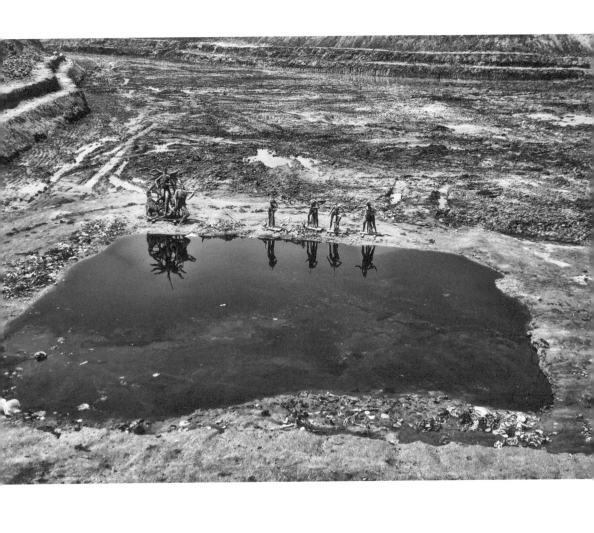

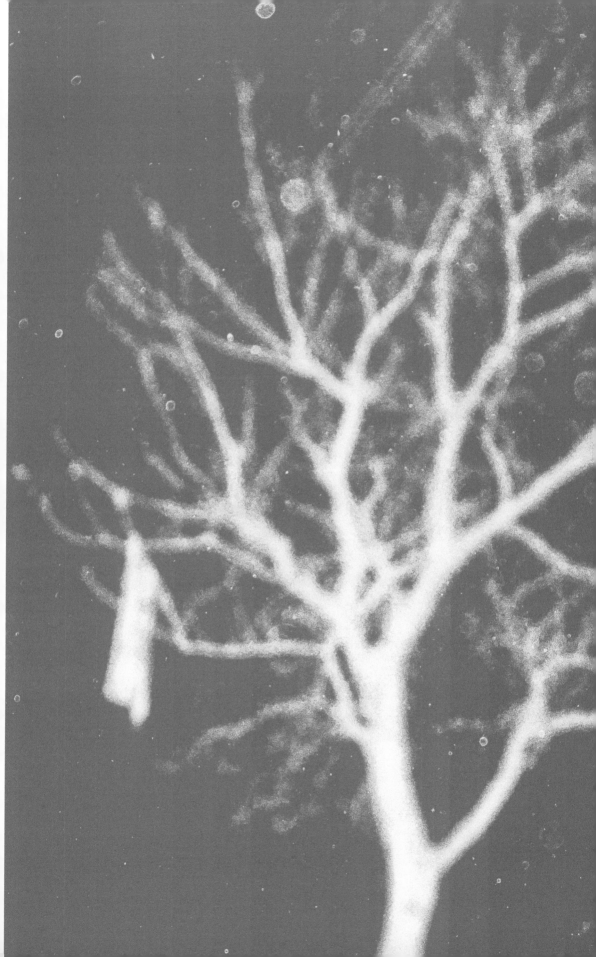

bodiless is the wind
clouds, lightning, thunder . . .
all bodiless

níl colainn ag an ngaoth
gan cholainn iad go léir . . .
néalta, tintreach, toirneach

may my body be vigorous
my tongue sweet!
may I hear abundantly

go raibh mo cholainn lúfar
mo theanga milis!
mo chluasa géar

students of sacred knowledge
come unto me!
hail!

an té atá ag foghlaim na gaoise
tagadh sé chugamsa!
fáilte!

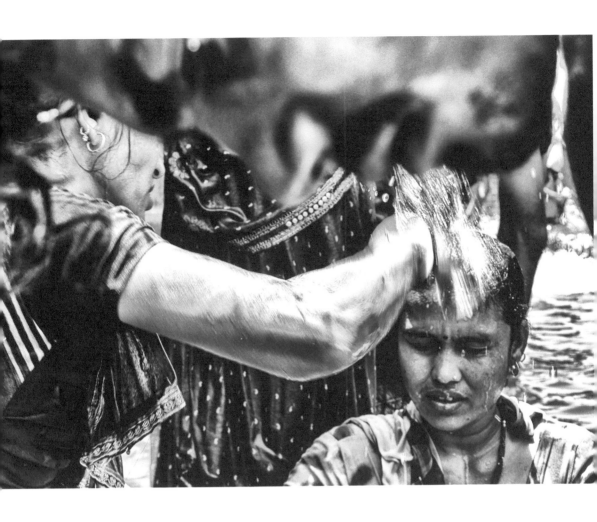

mover of the tree am I
like a mountain's peak
my fame!

is mé a bhogann an crann
mar bheann sléibhe
atá mo cháil!

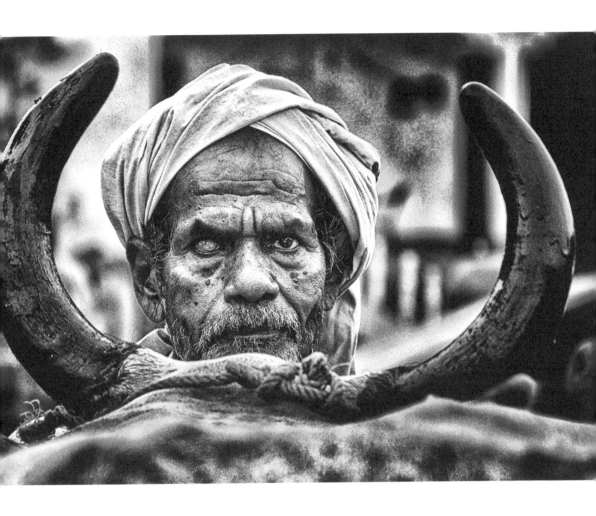

a shining treasure am I
wise, immortal . . .
indestructible

ciste lonrach mé
gaoismhear, neamhbhásmhar . . .
dochloíte

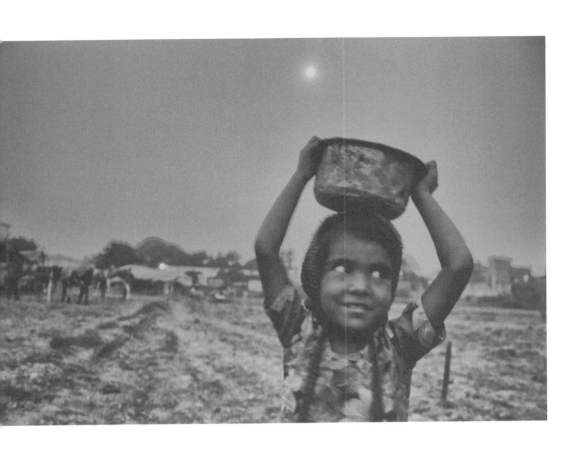

this Soul of mine
within the heart . . .
greater than the earth

an tAnam seo
istigh im' chroí . . .
is mó é ná an domhan

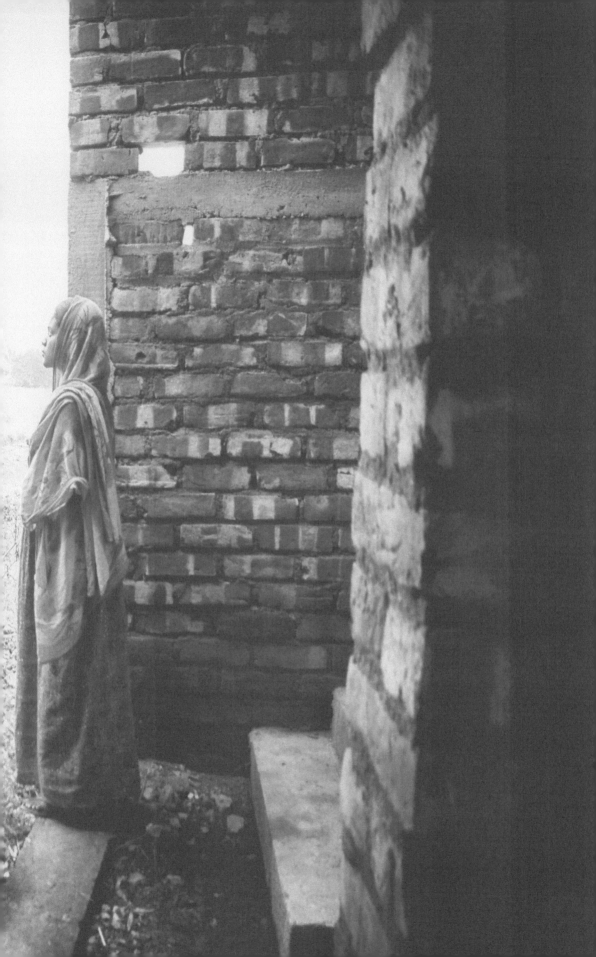

like corn
mortals ripen and fall . . .
like corn they come up again

ar nós arbhair
aibíonn daoine is titeann . . .
ar nós arbhair, tagaid arís

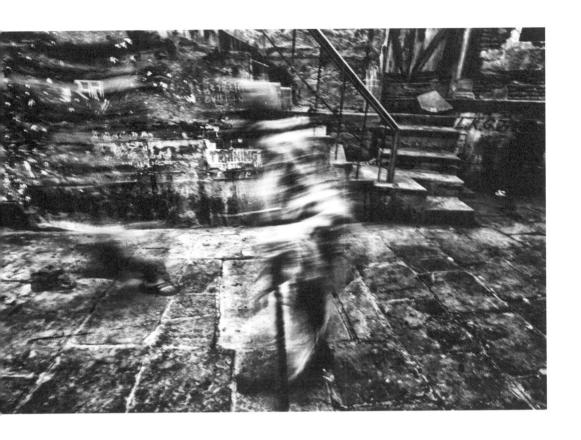

all faces are His faces
all heads, His heads . . .
all necks, His necks

gach aghaidh a aghaidh siúd
gach ceann a cheann siúd . . .
gach muineál a mhuineál siúd

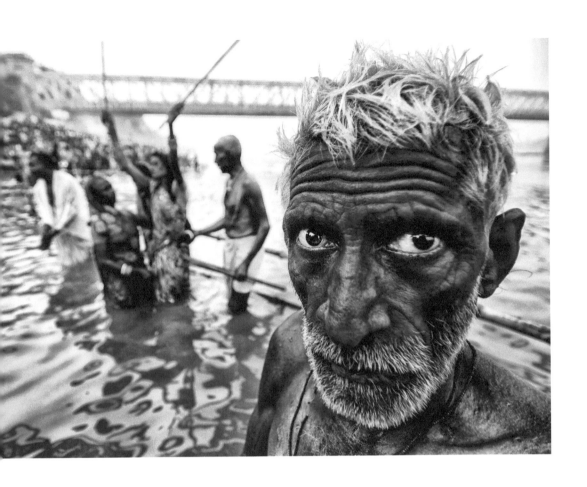

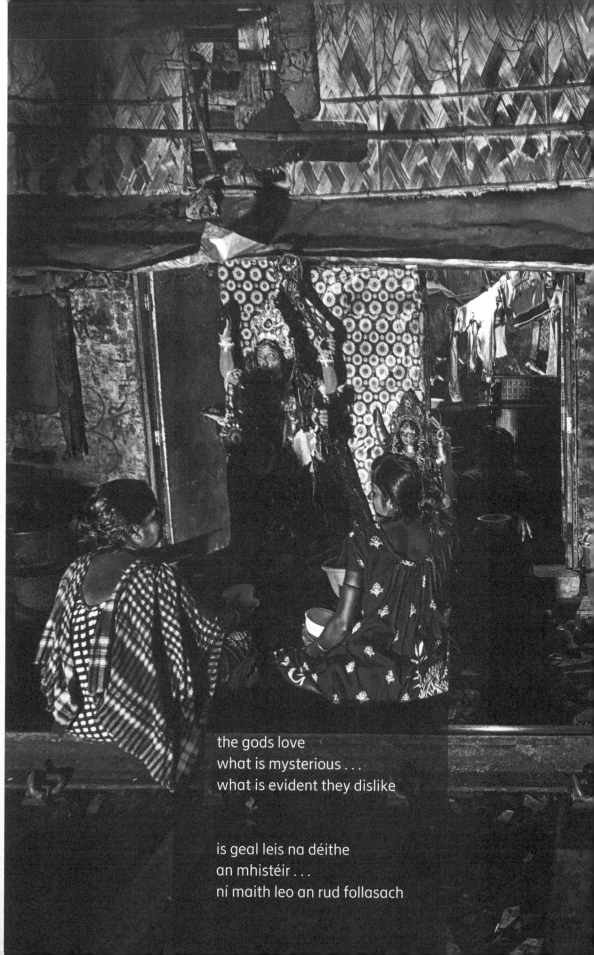

the gods love
what is mysterious . . .
what is evident they dislike

is geal leis na déithe
an mhistéir . . .
ní maith leo an rud follasach

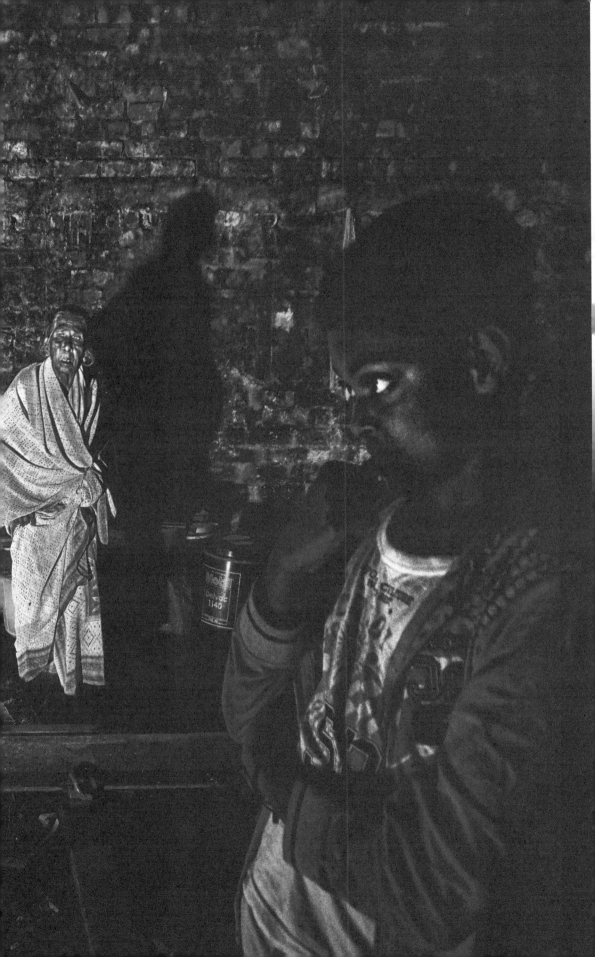

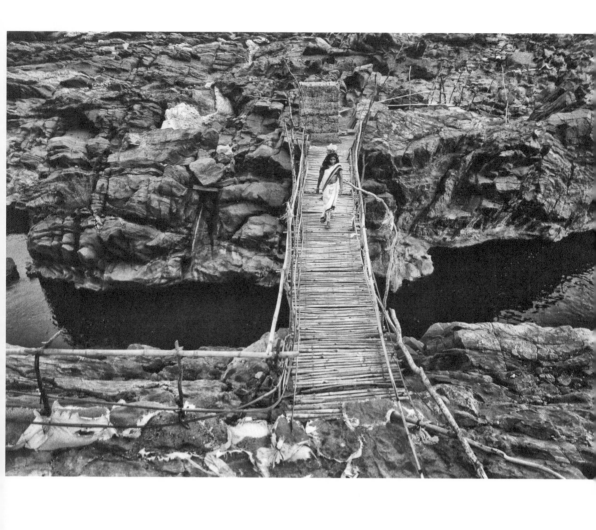

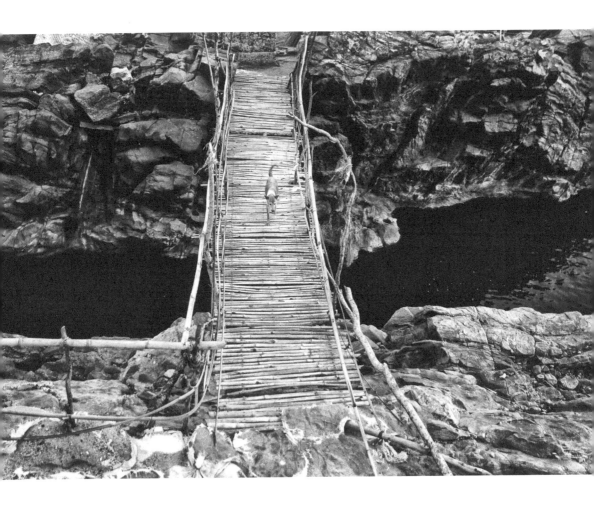

a little space
within the heart . . .
the heavens and the earth are there!

spás beag
sa chroí istigh . . .
tá na flaithis agus an domhan ann!

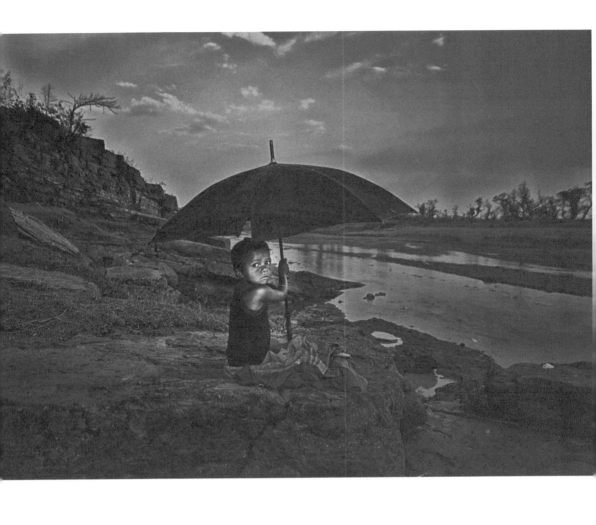

many never hear of the Self . . .
many hear
but do not understand

is beag duine a chloiseann faoin bhFéin . . .
má chloiseann siad
ní thuigeann siad

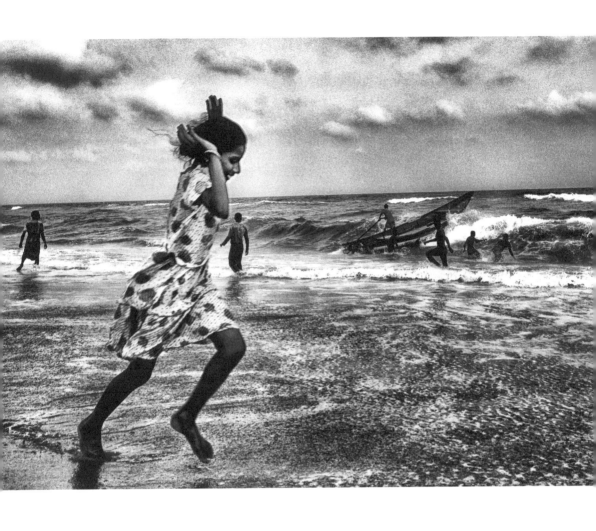

words cannot reveal him
mind cannot reach him . . .
eyes see him not

ní nochtann briathra é
ní shroicheann aigne é . . .
ní fheiceann súile é

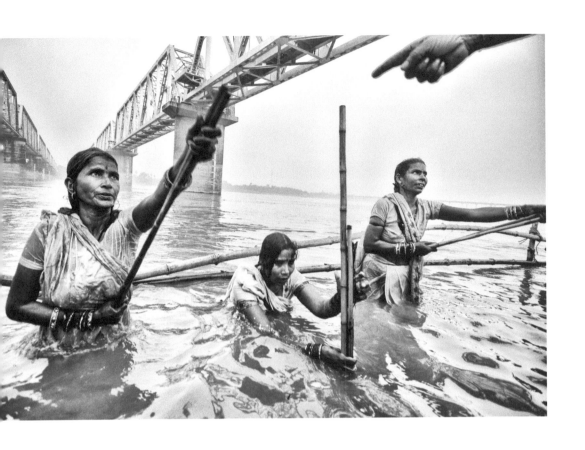

the one light is he
that gives light to all . . .
he shines, everything shines

eisean an t-aon solas
a shoilsíonn an uile ní . . .
lonraíonn seisean, lonraíonn gach rud

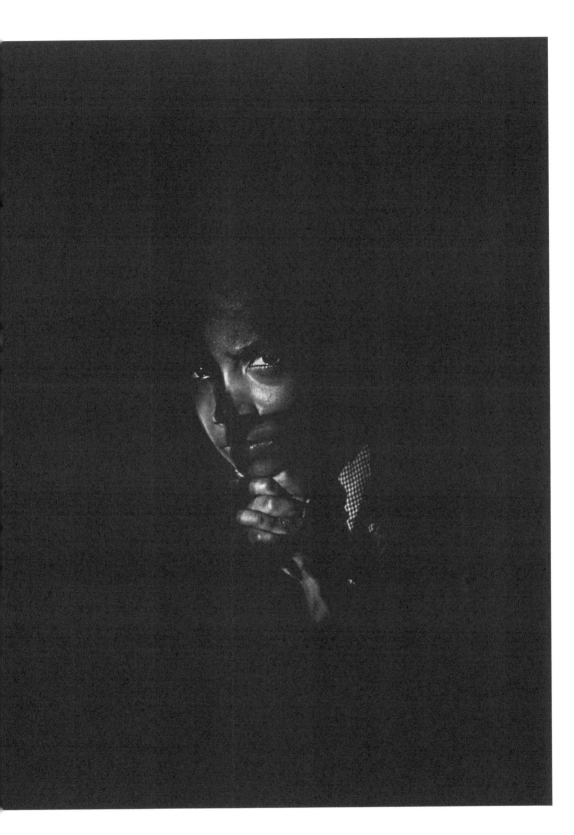

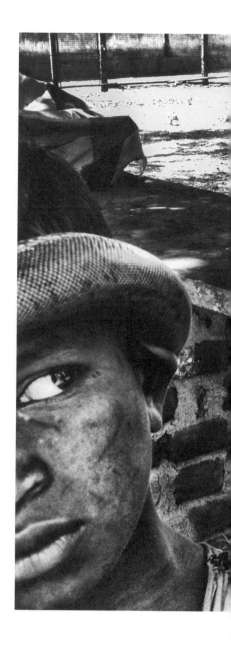

everything that moves
breathes, opens, and closes . . .
lives in the Self

gach rud a bhogann
a análaíonn, a osclaíonn, a dhúnann . . .
maireann san Fhéin

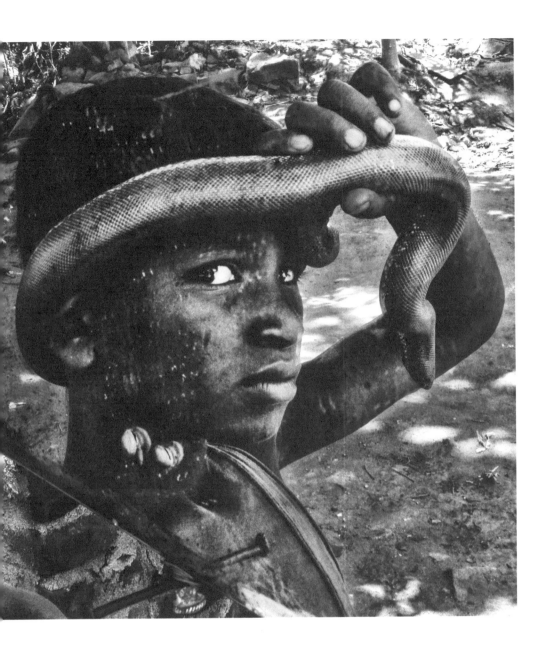

in the golden city of the heart
dwells the Lord of Love
without parts, without stain

i ngairdín órga an chroí
a chónaíonn Tiarna an Ghrá . . .
gan páirteanna, gan smál

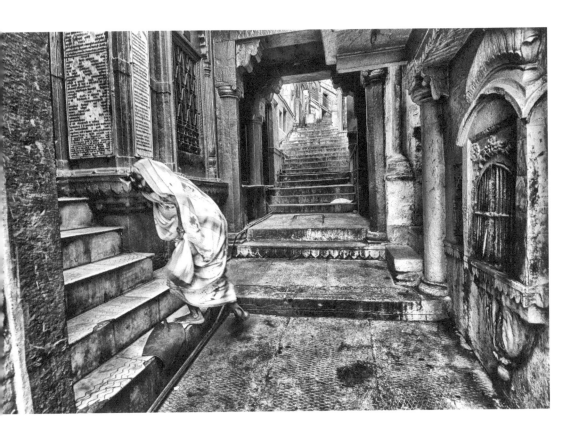

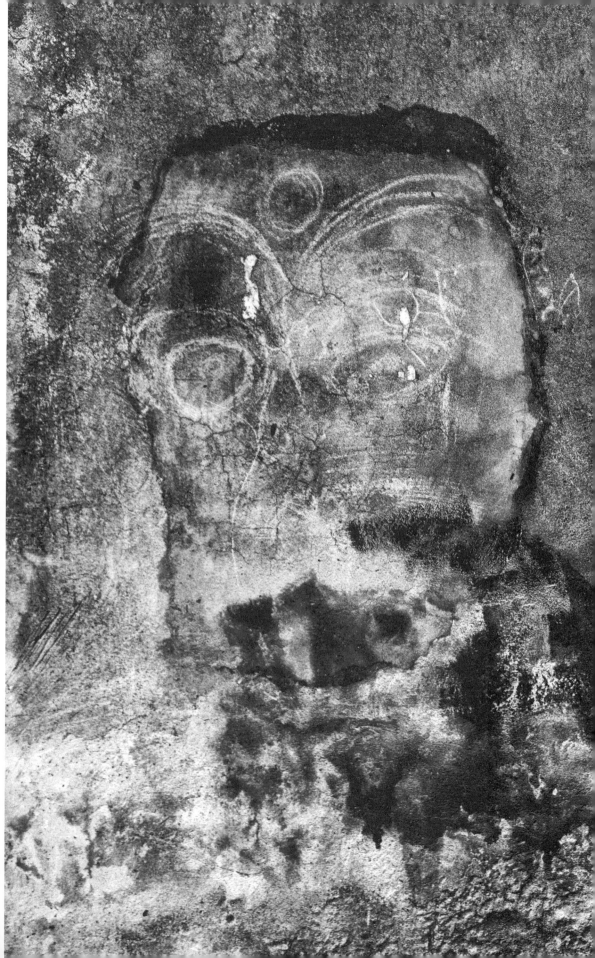

water becomes one with water
fire with fire, air with air . . .
mind one with Infinite Mind

déantar uisce d'uisce
tine de thine . . .
Aigne Shíoraí den aigne

you are the supreme Brahman, infinite
yet hidden in the hearts
of all creatures

tusa an Neach is Airde, síoraí
ach i bhfolach i gcroí
gach neach

the Self reveals himself
to the one
who longs for the Self

nochtann an Féin é féin
don té atá ag tnúth
leis an bhFéin

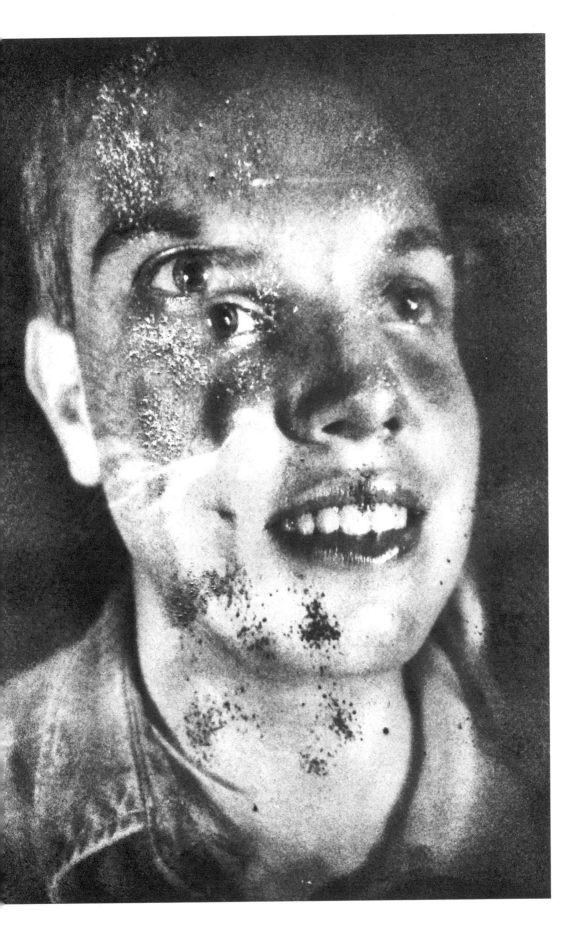

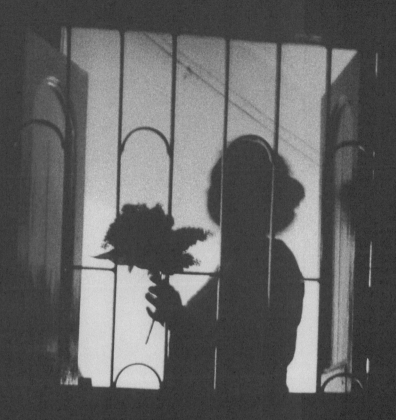

in deep meditation
aspirants may see forms . ..
like snow or smoke

i mbun dianmhachnaimh dó
d'fhéadfadh machnóir nithe a fheiscint . ..
sneachta, gal

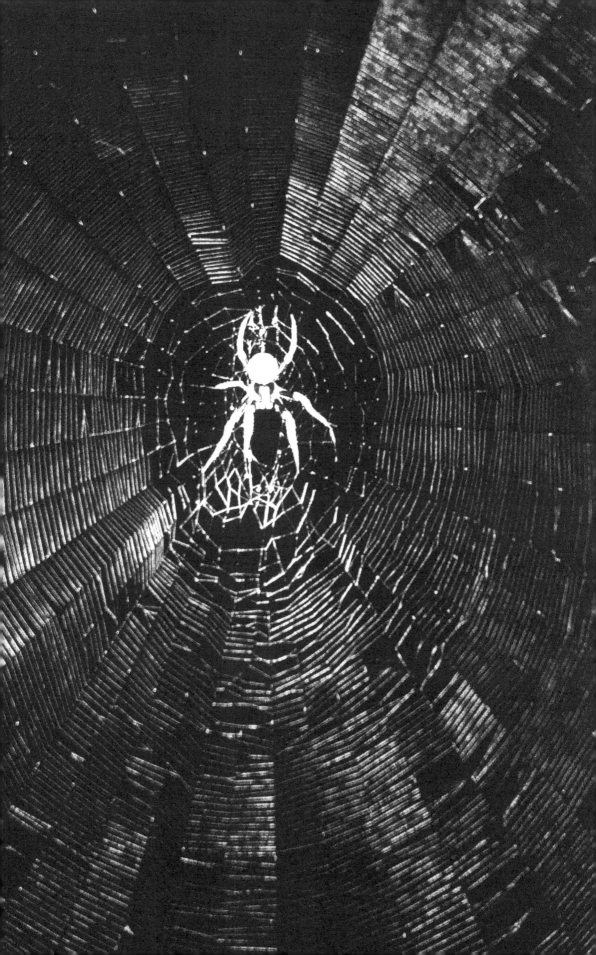

meditate on him as OM . . .
cross the sea of darkness
at ease

machnaigh air mar OM . . .
cuir an mhuir dhorcha dhíot
gan dua

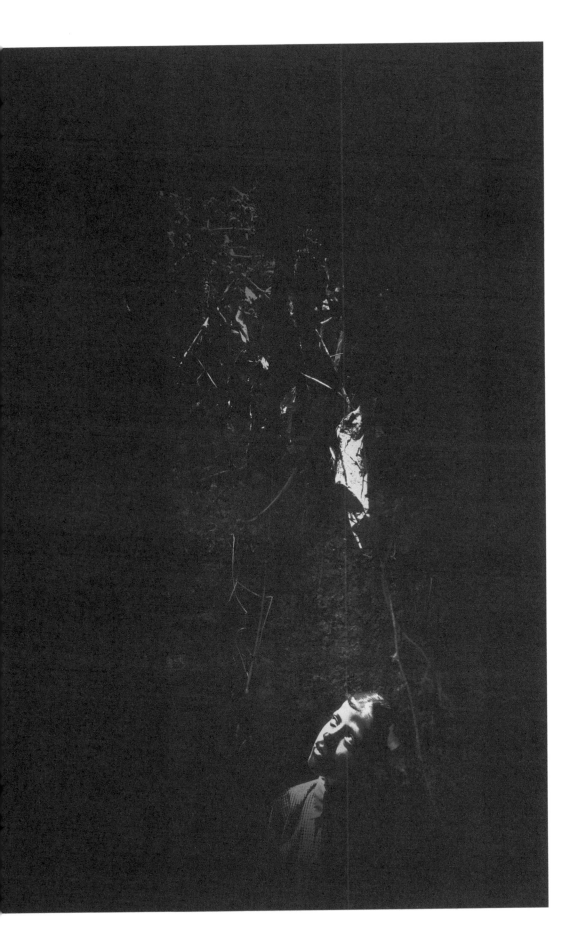

The Mundaka Upanishad. The Second Mundaka.
Second Khanda. Verse 2.2.6

अरा इव रथनाभौ संहता यत्र नाड्यः स एषोऽ न्तश्चरते बहुधा जायमानः।
ओमित्येवं ध्यायथ आत्मानं स्वस्ति वः पाराय तमसः परस्तात्

The Dynamics of Upanishadic Photo-Haiku Collaboration

I greatly enjoy some of the early English-language translations of Oriental classics, such as those made by Robert Ernest Hume (whilst not always sharing his view of the material, which can border on the condescending).

For Schopenhauer, the Upanishads were life's deepest consolation, and he hoped their guidance would be there for him at his hour of death. ('*Es ist die belohnendste und erhabenste Lektüre die auf der Welt möglich ist: sie ist der Trost meines Lebens gewesen und wird der meines Sterbens sein . . .*)

Nothing, says the great German philosopher could be more rewarding, more sublime than spending time with the Upanishads and the wisdom of the forest sages! Where better to go, therefore, than to India, the home of this universal wisdom, and to Kolkata's master photographer, Debiprasad Mukherjee. We had created photo-haiku projects before and both of us longed to do a book together, one in which the photographs speak for themselves, the haiku speak for themselves and, together, they speak as a third voice, their energies lifting one to another plane. Rereading the Upanishads, passages came alive to me in a new way, as 'found haiku'.

Photo-haiku is a magical brew. Debi's photographs are magical, the Upanishads are magical, and there is also a magic associated with three lines. Bring them together and you have enough magic to illuminate the whole world.

In ancient Ireland, the three-line utterance is known as a tré, or triad. The three most magical sounds?
 géim bó
 meilt bró
 béic linbh
 lowing of a cow
 grinding of a quern-stone
 crying of an infant

The same spirit that moved the Irish triadist must surely have informed this ancient Indian triad, a triad formed in the Indo-European mind, a spirit still very much alive to poets and visionaries:

The three great mysteries:
air to a bird
water to a fish
man to himself

Ancient languages have inherent magic too, Sanskrit and Irish, for instance. May they never be forgotten and may their treasures be known. The new science of ecolinguistics reminds us that the ancients have keys to our future on Earth.

GR

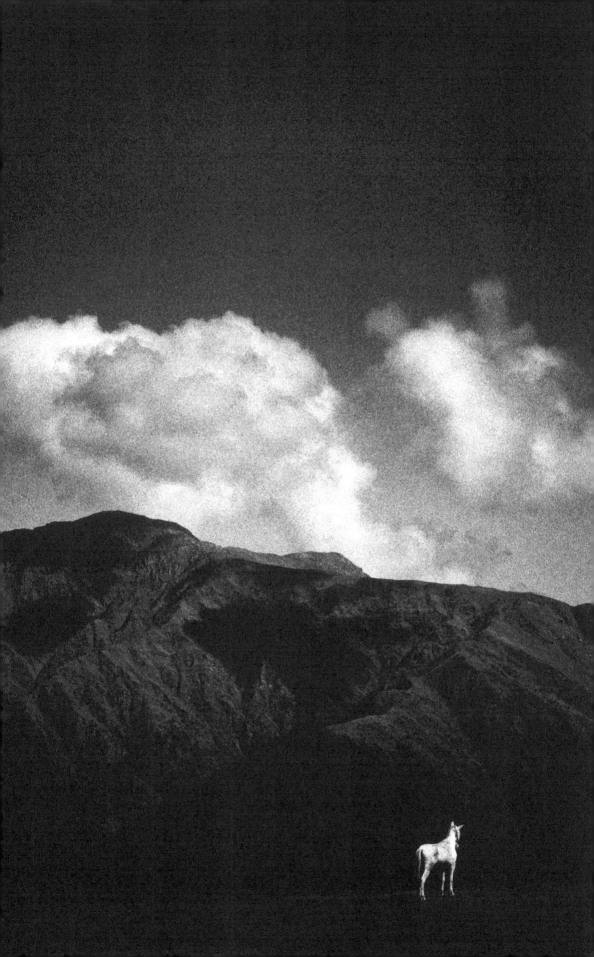

Epilogue: What is Found Haiku?

Ireland's greatest Anglophone poet, W.B.Yeats, brought out an edition of The Ten Principal Upanishads, with Shree Purohit Swami, in 1937 of which a reviewer in The Listener wrote:

> 'This is a book to be read slowly and lovingly,
> for it is full of grand passages and haunting phrases
> from those ancient sages who have left us some of
> the profoundest reflections ever made upon the nature of man.'

It is appropriate, therefore, that we should turn to Yeats again to briefly answer the question, what is a found haiku?
Look at the opening of his gorgeous poem The Stolen Child:

> Where dips the rocky highland
> Of Sleuth Wood in the lake,
> There lies a leafy island
> Where flapping herons wake
> The drowsy water rats . . .

There is so much melody in Yeats — such Yeatsiness of phrasing — it seems like sacrilege to paraphrase or truncate the language in any way, but this type of surgical operation is needed if we wish to create a 'found haiku':

leafy island . . .
flapping herons wake
the drowsy water rats

So, there you have it, in a nutshell. The Stolen Child has provided us with a found haiku and what the extracted text has lost in dreamy music, it has gained in focus! A haikuist can train himself to discover 'found haiku' in all sorts of texts, not just verse:

the river runs so strong . . .
it keeps the bridge
shaking

That's a 'found haiku' from the journals of Gerard Manley Hopkins. Haiku can be 'found' in this way — sometimes with hardly any alteration at all — in novels, diaries, letters, short stories, plays, sermons, scriptures and so on.

If the 'found haiku' in this book prompt some readers to read the full text of the Upanishads for themselves, so much the better.

GR

In The Stars Are His Bones, Gabriel unearths 'found haiku', golden nuggets of lyrical beauty, in the ancient texts of the Upanishads, with their uncanny echoes of the Irish poetic tradition of the triad. Focusing on Eye, Ear, Mind and Breath — he creates gorgeous little songs that bridge the human and the divine. Perfectly matched with the in-the-moment potency of Debiprasad's photographs, this is a brilliant artistic fusion that reveals poetry on 'the edge of a razor'.

Liam Carson. Director, IMRAM Irish Language Literature Festival

Indian documentary photographer Debiprasad Mukherjee and Irish bilingual author Gabriel Rosenstock have joined forces to produce an atmospheric photo-haiku monograph infused with the wisdom of Upanishadic texts. The harmonious interplay of ethereal imagery and heartfelt poetry transports us to a magical world of ancient Gods and sublime beauty — a thoroughly rewarding and cathartic aesthetic experience.

Kon Markogiannis. Visual artist, author of "Dysturban"

Debiprasad Mukherjee's photographs are saturated with the sweat of fundamental human experience whilst at the same time suffused with the breath of beingness itself. Gabriel Rosenstock sees the beingness of each photograph and honours it with a haiku composed with a stir of the Upanishads. This collaboration is a gift for those who see with -- or wish to awaken -- the original eye behind the eyes.

Jerry Katz. Author & nondualist

In his introduction to the work of the great Indian poet, Rabindranath Tagore in 1913, W B Yeats said of that Indian-Irish encounter: 'A whole people, a whole civilization, immeasurably strange to us . . . and yet we are not moved because of its strangeness, but because we have met our own image. ' This beautiful book is a shining example of that supreme recognition.

Jack Harrison. Founder. The Celtic School of Yoga

Haiku and photography what a nice meeting. sublimated form of poetry with the synthetic narrative of the image. I've always dreamed of being able to work with the image on words, now it's done. Mukherjee and Rosenstock give us an elegant book, a look beyond the horizon of the obvious.

Stefano De Luigi. Four times World Press Photo awards winner photographer & member of VII Photo Agency

I shut my eyes and all the world drops dead/I lift my eyes and all is born again' renowned poet Sylvia Plath wrote more than half a century ago. The Stars Are His Bones, a volume of haunting imagery and text, reinforces this beautiful and universal truth.

Dr. Mícheál Ó hAodha. Irish-language poet

Debiprasad's lens becomes a photo-weaving machine and Gabriel's verses act as a fine thread that stitches its parts: together they become vibrant generators of emerging and dissolving spatial atmospheres.

Spyridon Kaprinis. Senior Lecturer, London South Bank University

穿过这些充满人文主义悲悯之心的诗性化影像，我看到一个承载着真与善的纯净灵魂。摄影家与诗人的作品相得益彰，这是两位艺术家对那片土地最深沉的爱，也是对人类生命的虔诚礼赞

Fu Weixin. Director & Curator of Photography Museum of Lishui, China & Lishui Photo Festival

Mukherjee's photography is direct and intense. His black and white work is deep and raw and reminds us of the fragility of human beings

Giacomo Brunelli, Acclaimed Italian photo artist

What is it
that by being known
all else becomes known?
Mundaka Upanishad

Brevity, wit, a cosmic vision that transcends all boundaries: if these are signs of great poetry, here is great poetry in conversation with images that beautifully and meaningfully complement them. . . a visual and verbal treat for the best of readers.

K. Satchidanandan
Sahitya Akademi Award winner. Indian poet and bilingual literary critic

In The Stars Are His Bones the elemental and sacred are organically fused in a rush of wisdom and textured imagery. Words in Sanskrit are knowledgeably transposed by Gabriel Rosenstock into English and Gaelic (Irish), made tactile by the shadowy, feral images of Debiprasad Mukherjee. The scale is from the gnat to the elephant to the widening expanse of the universe. Cosmic stuff!

Seamus Murphy
Recipient of seven World Press Photo awards &
Member Photographer of VII Photo Agency

One of the most significant, recurring and underlying themes in Upanishads is the realization, not merely faith, in the inherently inter-connected, inter-woven and inter-dependent existence at the cosmic level, encompassing not just the entire humanity but also flora and fauna, all animate and inanimate entities in the physical universe. For contemporary society, afflicted by the fragmented, narrow view of self-interest and self-identity, this broad, universal and harmonizing, ancient Indian perspective is ever more relevant.

Renowned Irish poet Gabriel Rosenstock and young Indian photographer Debiprasad Mukherjee have created a fascinating Indo-Irish publication, weaving thoughts inspired by Upanishads in the Haiku structure, in English and Irish language poems, contextualized with sensitive visuals and imagery.

As the Ambassador of India to Ireland, I look forward to many more people-centric cultural and literary collaborative initiatives between India and Ireland for mutual enrichment.

Mr. Akhilesh Mishra
H.E Ambassador of India to Ireland

the stars are her bones
the clouds, her flesh
rivers are her entrails

réaltaí iad a cnámha
néalta a colainn
aibhneacha a hionathar

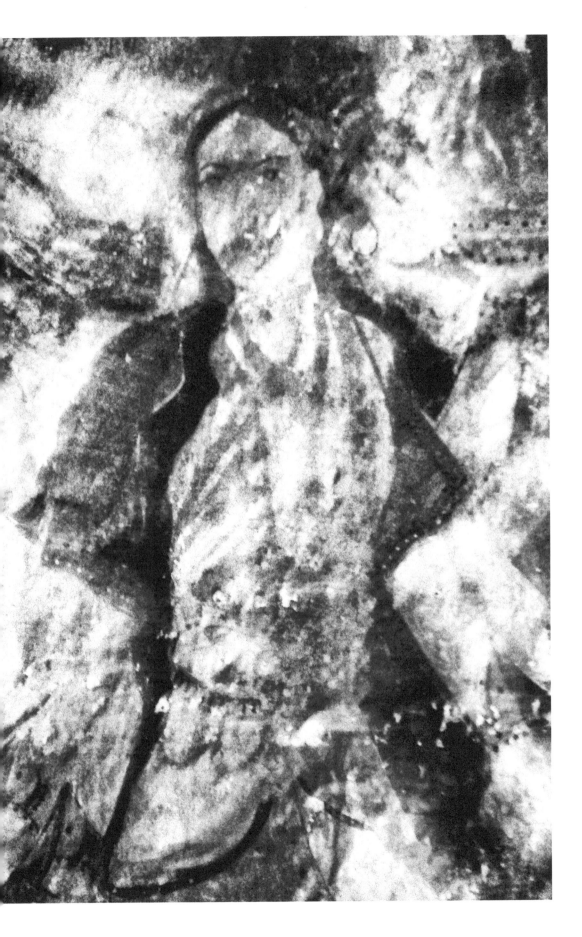

Photo Credit: Bill Wolak

Gabriel Rosenstock was born in postcolonial Ireland. He is a bilingual poet, tankaist, haikuist, translator, short story writer, novelist, playwright, essayist and, to borrow a phrase from Hugh MacDiarmid, 'a champion of forlorn causes'. Previous collaborative work with Debiprasad Mukherjee has appeared in The Irish Times, The Culturium and Margutte (See Ekphrastic Collaborations in Mukherjee's website). Rosenstock is a member of Aosdána (the Irish academy of arts & letters), a Lineage Holder of Celtic Buddhism and a recipient of the Tamgha-i-Khidmat medal for services to literature.

https://www.rosenstockandrosenstock.com/

Photo Credit: Monidipa Mukherjee

Debiprasad Mukherjee is an Indian photographer and visual story-teller. His passion towards visual journalism is not only to depict emotional, social, political and economic perspectives and multi-layered conflicts but also to portray surreal beauty and the enduring power of the human spirit. Debiprasad was the convener of the first Kolkata International Photography Festival, represented World Climate Summit Madrid 2019 as Global Carbon Ambassador and author of "Sound of Silence". He exhibited his works in more than 20 countries and published in 15+ international magazines & websites.

https://debiprasadmukherjee.com/

Lightning Source UK Ltd.
Milton Keynes UK
UKHW052205190422
401761UK00002B/82